LON
PATRICK KEILLER
DON

FUEL

Preface

During the early 1990s, I realised a film called *London*. Photographed during 1992 and completed in January 1994, it comprises 356 moving images of places and events edited from over seven hours of silent 35mm footage, arranged in more or less chronological order together with narration, post-synchronised ambient sound and, occasionally, music. The narration, written after the picture had been photographed and edited, is a fictional account of efforts by an unseen would-be scholar, Robinson, to identify the 'problem' of London, related by his similarly unseen companion whose words were spoken by the late Paul Scofield.

In the summer of 2019, Damon Murray and Stephen Sorrell of FUEL asked me if I might be interested in working with them to prepare a book based on the film. The suggestion appealed firstly because the film's narration had never been published, and secondly because, not long before, its negative had been scanned to enable digital distribution to cinemas, so that for the first time it was relatively easy to obtain high-definition frames for publication. The book includes 209 of these, together with the narration, an afterword, and a list of camera subjects and endnotes.

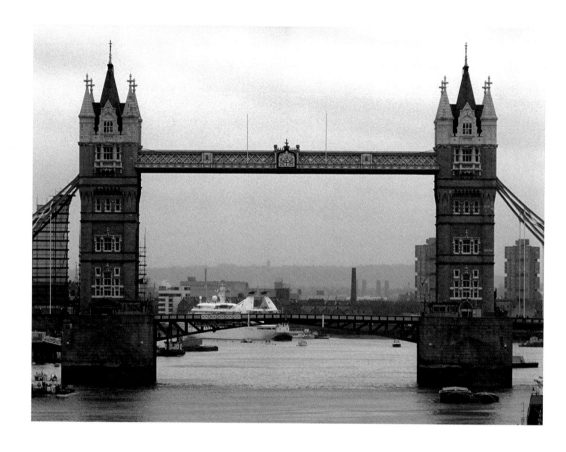

11 JANUARY 1992

It is a journey to the end of the world...

It is seven years since I last saw Robinson, on the day I left England, when he saw me off at the quayside.

I have heard from him from time to time during my travels, but now he has written that he urgently wishes to see me, that he is on the verge of a breakthrough in his investigations, and that I should come as soon as possible, *before it is too late...*

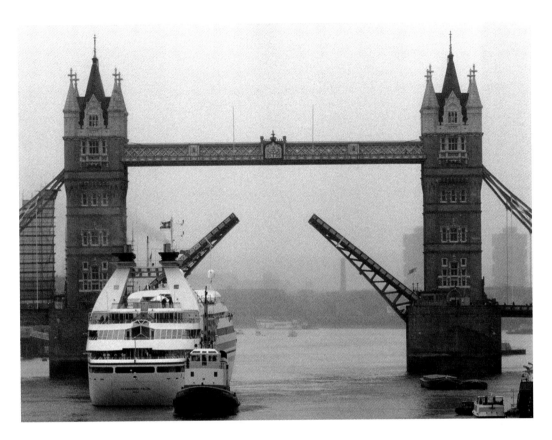

THE GREAT MALADY — HORROR OF HOME [1]

Dirty Old Blighty —

undereducated, economically backward, bizarre — a catalogue of modern miseries...
with its fake traditions
its Irish war
its militarism and secrecy
its silly old judges
its hatred of intellectuals
its ill health and bad food
its sexual repression
its hypocrisy and racism
and its indolence

it's so *exotic*, so *home-made*!

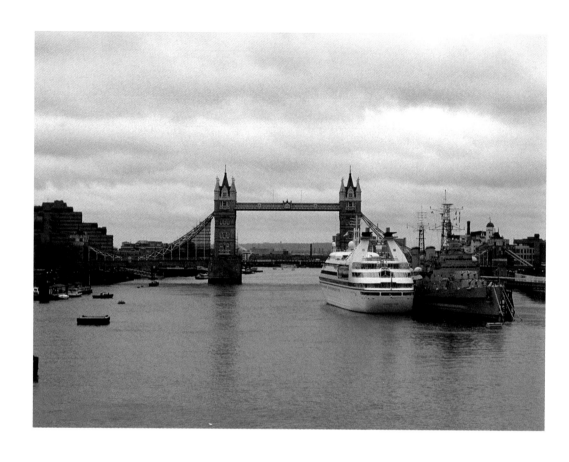

I have arrived as ship's photographer on a cruise ship, in which the berths cost four thousand pounds a week...

Robinson lives in the way that people were said to live in the cities of the Soviet Union. His income is small, but he saves most of it.

He isn't poor because he lacks money, but because everything he wants is unobtainable...

He lives on what he earns in one or two days a week teaching, in the school of fine art and architecture of the University of Barking.

Like many autodidacts, he is prone to misconceptions about his subjects, but as there is no one at the university to oversee him, his position is relatively secure.

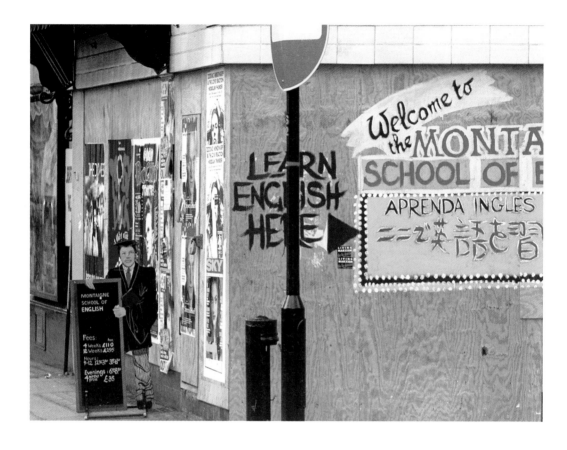

Robinson reads Montaigne: 'It is good to be born in depraved times, for by comparison with others you are reckoned virtuous at little cost.'[2]

It is not *generally agreed* that Montaigne lived for a time in London, in a house in Wardour Street, the first of a number of French writers who found themselves exiled here.[3]

Robinson studies the work of this group...

Mallarmé, who lived nearby; Rimbaud and Verlaine; Marcel Schwob, the translator of Defoe, De Quincey and Robert Louis Stevenson; and Baudelaire, who translated Edgar Allan Poe.

(Baudelaire, of course, never actually set foot in England, but his mother was born in London and spoke English as a child.)

Apart from his academic work, Robinson hardly ever leaves the flat except to go to the supermarket.

When he used to visit friends abroad, his social life was transformed — he became an enthusiastic flâneur, astonishing his hosts with his stamina and generosity, but for several years he has not left the country, as he wrestles with what he calls the 'problem' of London.

For him, shopping is an experience of overwhelming poignancy, as the labels on imported goods evoke such longing for the journeys abroad that he no longer feels able to make.

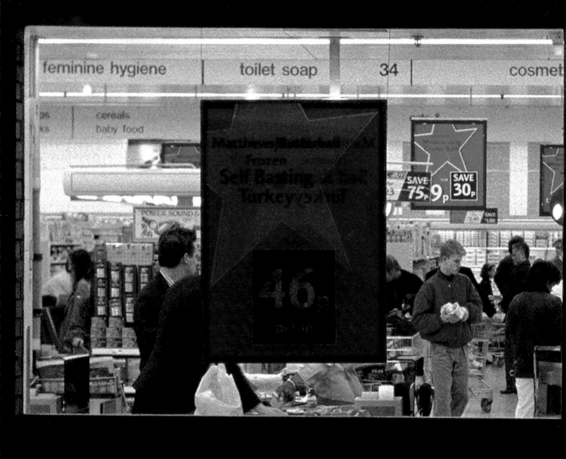

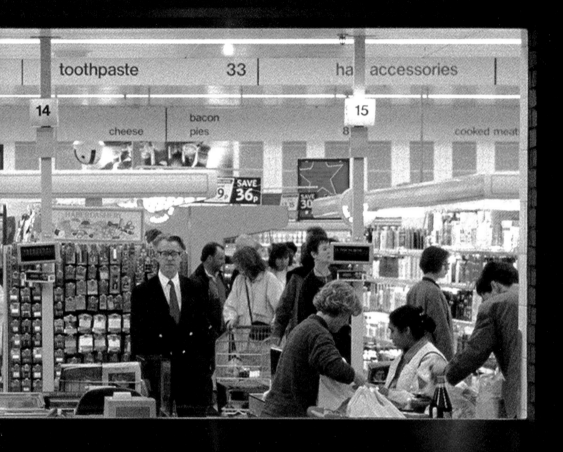

Robinson and I lived together for many years, during which we intermittently maintained an uneasy, bickering sexual relationship.

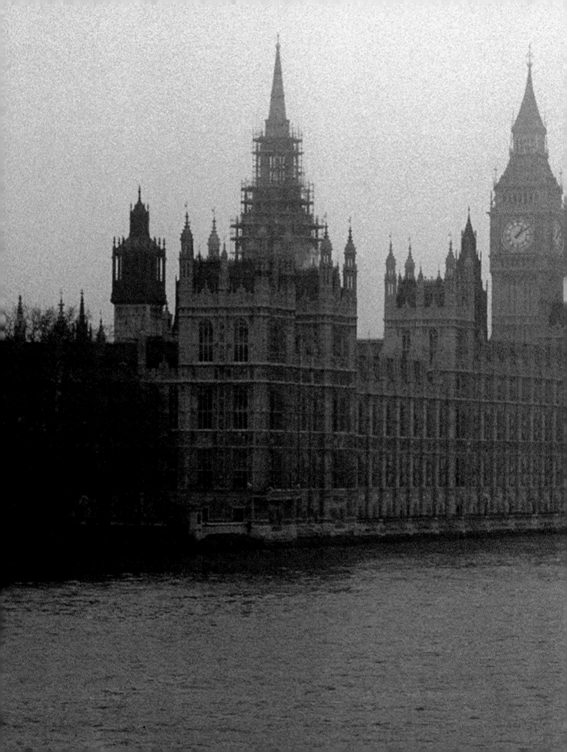

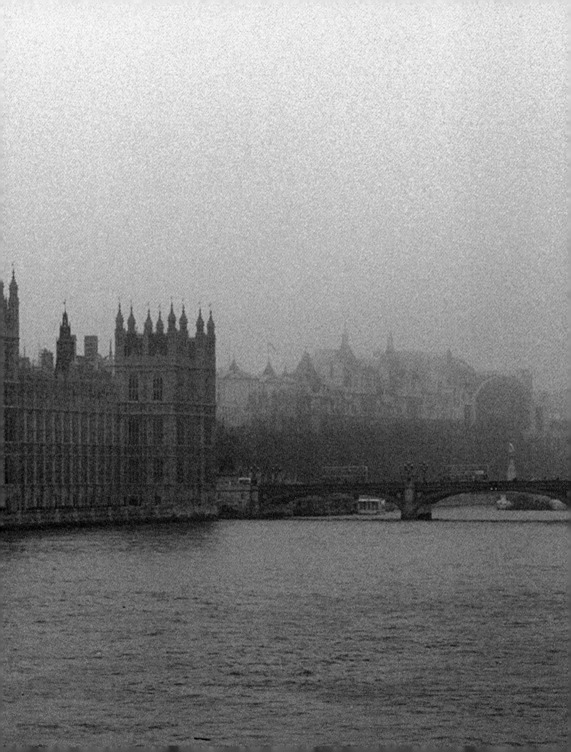

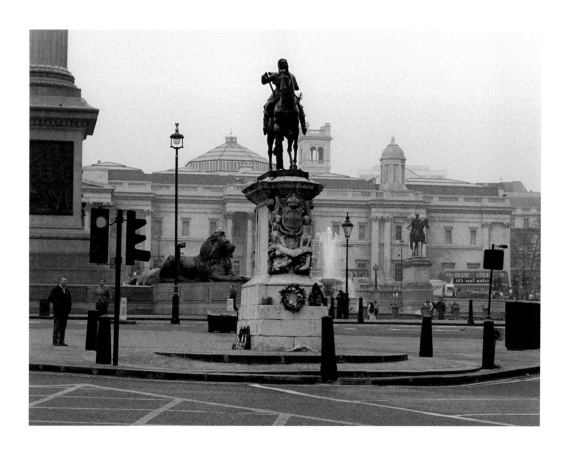

Robinson is a supporter of constitutional reform. On January 30th, we took the bus to Whitehall...

It is the three hundred and forty-third anniversary of the execution of King Charles I by the revolutionary government of 1649.

Every year groups of Anglo-Catholics and other ultra-monarchists lay wreaths at his statue before holding a ceremony at the Banqueting House, where the king was beheaded on a scaffold set up outside one of the windows.

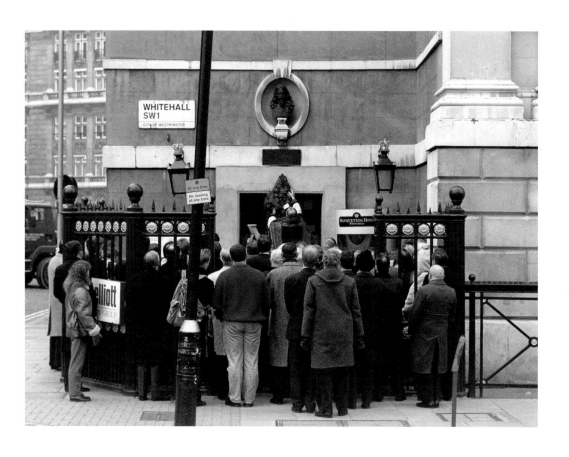

'The failure of the English Revolution,' said Robinson, 'is all around us — in the Westminster constitution, in Ireland, and poisoning English attitudes to Europe.'

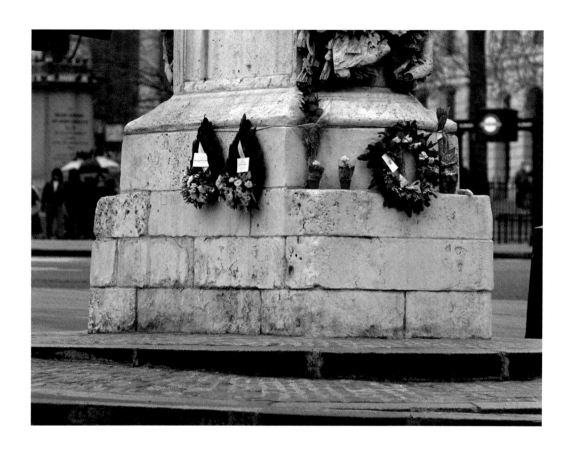

The wreaths remained hanging on the statue's plinth for several weeks, during which I gradually renewed my familiarity with the city.

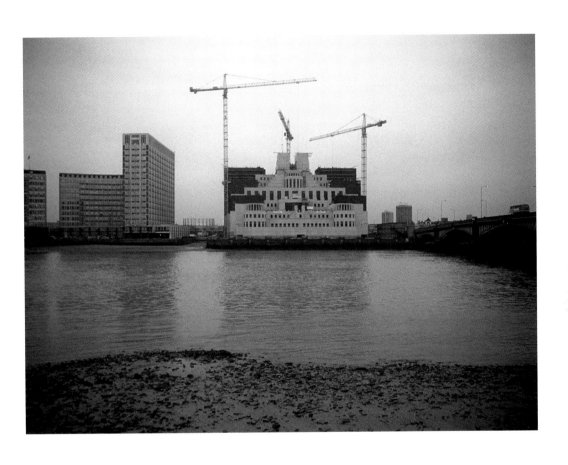

Everywhere we went, there was an atmosphere of conspiracy and intrigue.

VAUXHALL

Robinson lives in Vauxhall, a district famous for its associations with Sherlock Holmes.[4]

He listens to the gateposts at the entrance to the park.

Robinson is worried about the future of the park; about the buses: the 2B from Baker Street and Victoria, and the 88 from Oxford Circus and Westminster; and about the library, all of which will be under threat if the government does not lose the election...

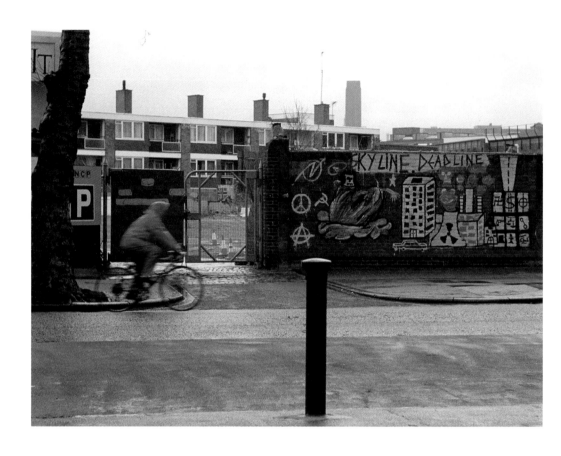

THE ROMANTIC

Robinson explained to me the nature of his project, and took me to some of the sites he was studying.

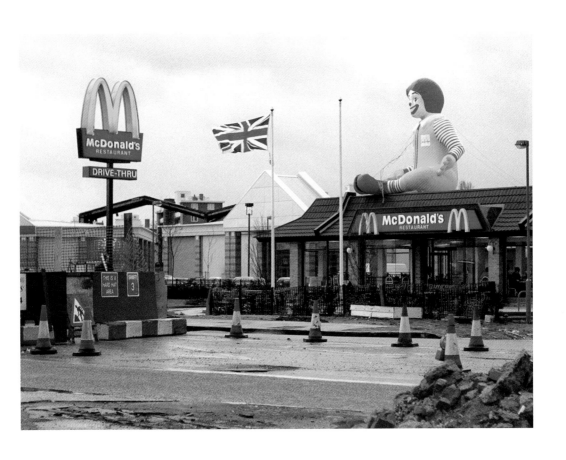

'Romanticism,' wrote Baudelaire, 'is precisely situated neither in choice of subjects nor in exact truth, but in a mode of feeling.'[5]

For Robinson, the essence of a romantic life is in the ability to *get outside oneself*, to see oneself *as if from outside*, to see oneself, as it were, in a romance.

He was searching for the location of a memory, a vivid recollection of a street of small factories backing on to a canal...

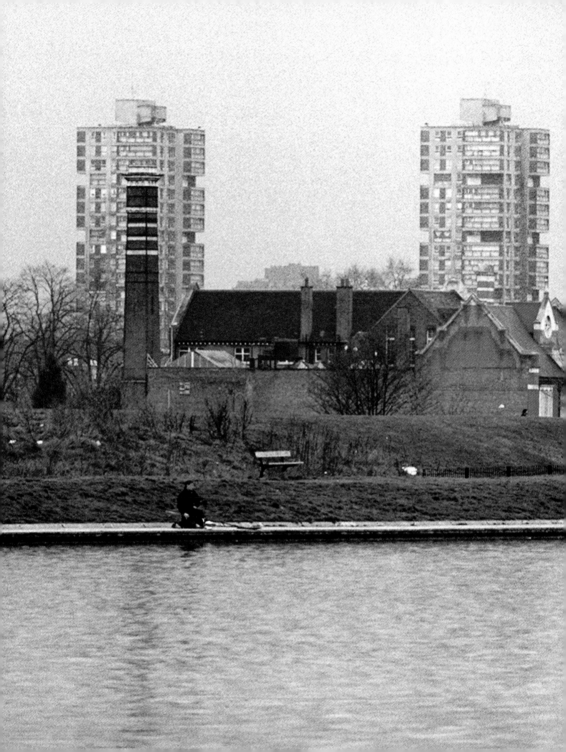

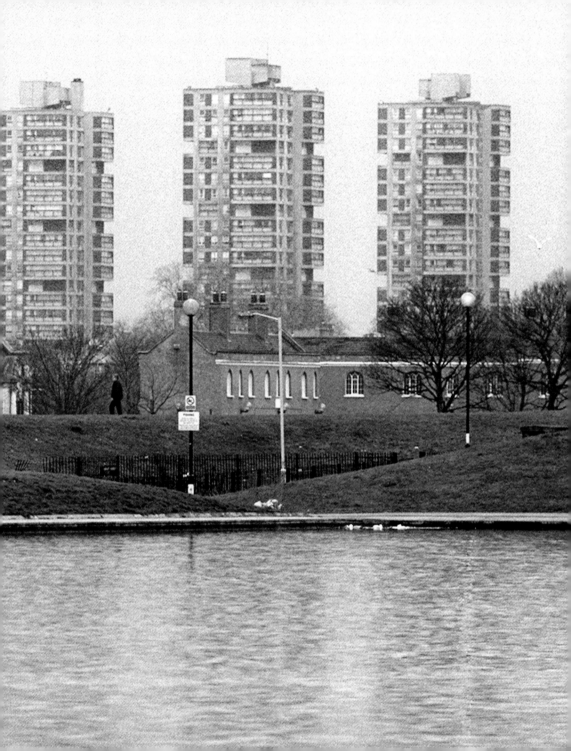

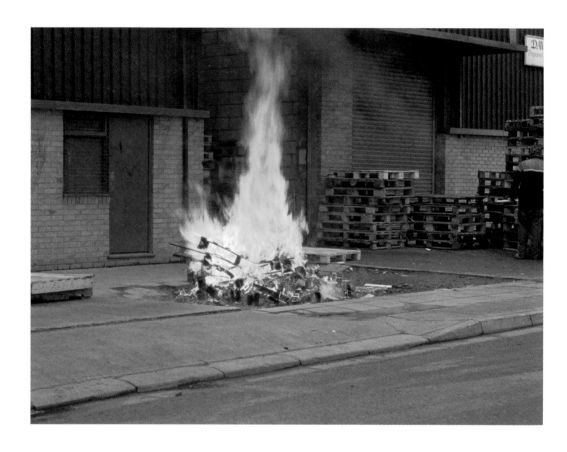

But they no longer exist, and he has adopted the neighbourhood as a site for exercises in psychic landscaping, drifting and free association.

He seemed to be attempting to travel through time...

I had the idea that he had sent for me to be the witness and chronicler of these explorations, in what he thought might be the last months of his life.

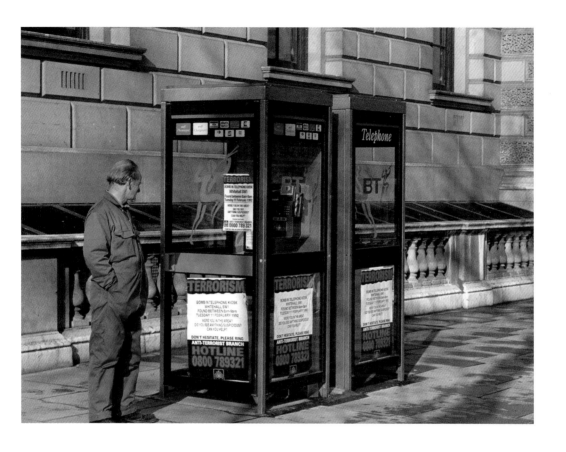

Robinson is not a conservationist, but he misses the smell of cigarette ash and urine that used to linger in the neo-Georgian phone boxes that appear on London postcards.

He is preparing his own series of postcards of contemporary London. We visited Lincoln's Inn Fields, and he asked some of the residents to pose for him.

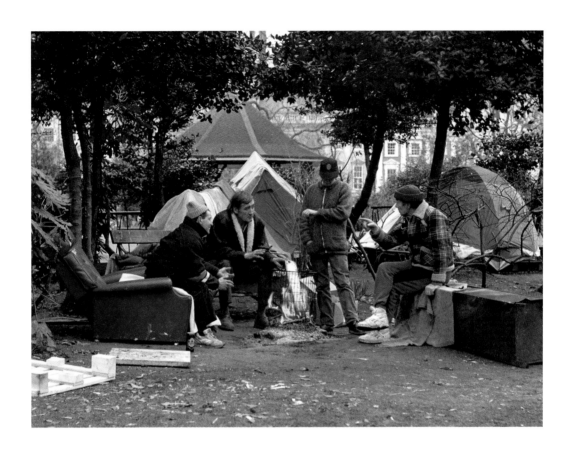

I was shocked at the increase in the numbers of people sleeping out in the seven years
I had been away, but Robinson seems quite accustomed to it. He rarely gives anyone
money, at least not when I am with him.

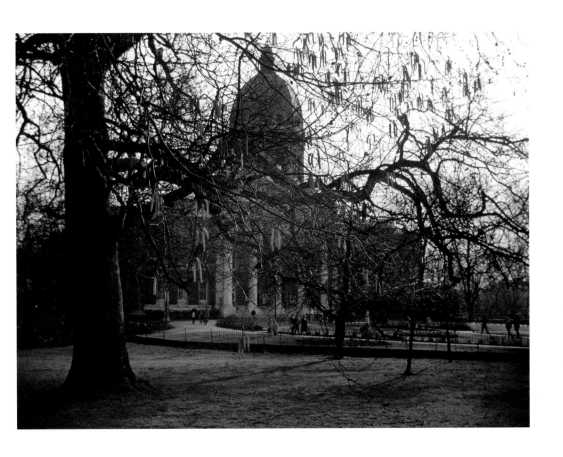

He took me to the War Museum, formerly Bedlam, the Bethlem Royal Hospital for the care of the insane.

He told me that many of the homeless who sleep out in central London are ex-servicemen and women, or former psychiatric patients.

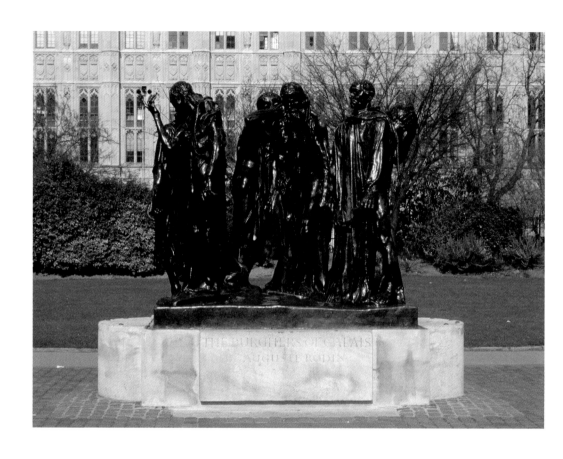

'London,' he says, 'is a city under siege from a sub-urban government, which uses homelessness, pollution, crime, and the most expensive and run-down public transport system of any metropolitan city in Europe, as weapons against Londoners' lingering desire for the freedoms of city life.'

Across the road from Robinson's flat, in what used to be a video shop, a driving school has opened, run and mostly patronised by Portuguese people, who have settled in the district increasingly in the past few years.

Robinson has decided we should get out more. He had thought that he might learn to drive, but now he says it will be better if we walk...

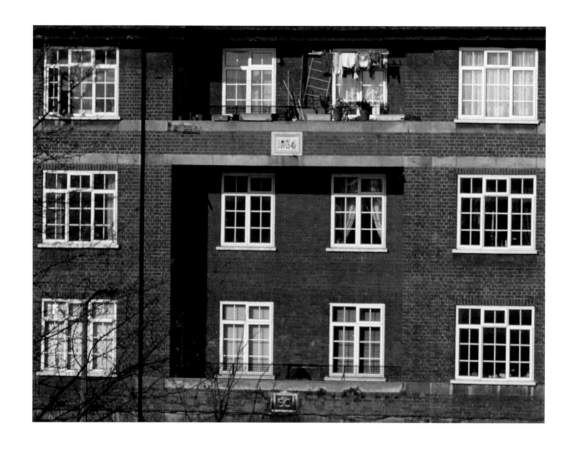

He has asked me to accompany him on a series of journeys, each one prompted by an aspect of his project.

The first is to be a pilgrimage to the sources of English Romanticism.

On March 10th we set out for Strawberry Hill, the house of Horace Walpole, but were distracted by events on Wandsworth Common...

The bomb had gone off at 7:10 that morning. We had heard the bang but had not realised what it was.

It was two days after the nineteenth anniversary of the bombs at the Old Bailey in 1973, the first IRA attack on London.

Again, having been away for such a long time, I found it strange how quickly these events are forgotten by the general public. When I asked him, Robinson could remember the mortar attack on Downing Street in February the year before, but not the eight or so devices since. He seemed to have become conditioned to the idea that what was happening in Ireland did not have much to do with him.

March 10th was budget day. In the afternoon, the chancellor of the exchequer produced a tax cut (smaller than expected) to complement the newspapers' stories about the opposition's spending plans.

On the following day, the election date was finally announced. With the City unimpressed by the budget, £10 billion were wiped off share values on the London Stock Exchange.

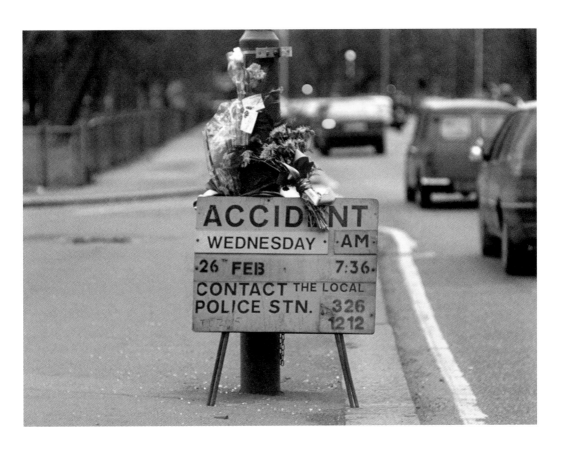

On March 12th we set off again, crossing Clapham Common in the rush hour.

STRAWBERRY HILL

Robinson took out his guide book: 'At Strawberry Hill, in 1765, Walpole wrote *The Castle of Otranto*, the novel that established the genre of English Gothic fiction.'

'The house is not far from Teddington Lock, the limit of the tidal river and, with it, the jurisdiction of the Port of London Authority...'

'Twickenham,' said Robinson, 'is the site of the first attempts to transform the world by looking at the landscape...'

In Radnor Gardens, we met two musicians from Peru, and had the idea that we should stay the night there, and walk with them to Brentford in the morning.

When we awoke, it was spring...

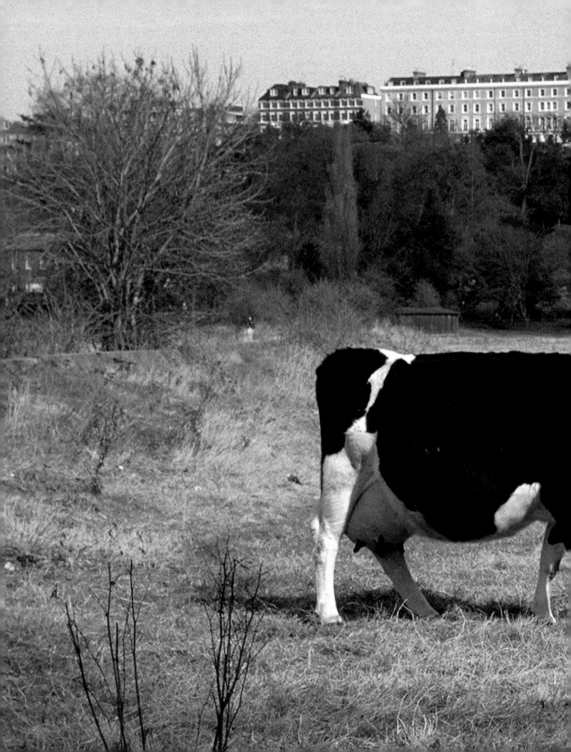

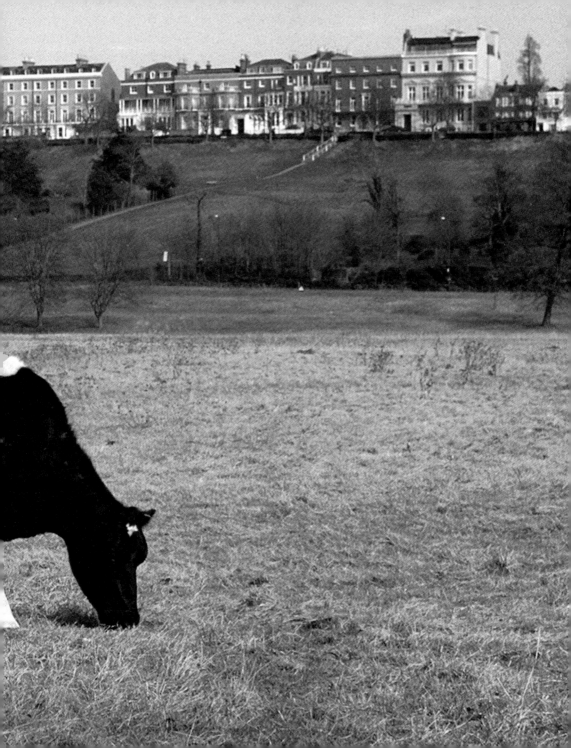

He told me that Turner used to walk along the river here, and showed me
Joshua Reynolds's house on Richmond Hill, with its view along the valley.

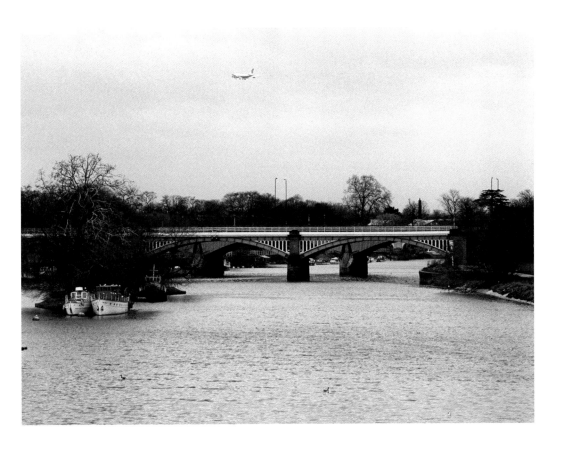

We left the river at Isleworth to detour around Syon Park, fearing violence from the owner's lackeys, and found ourselves in the old coach road to Bristol, a notorious haunt of highwaymen.

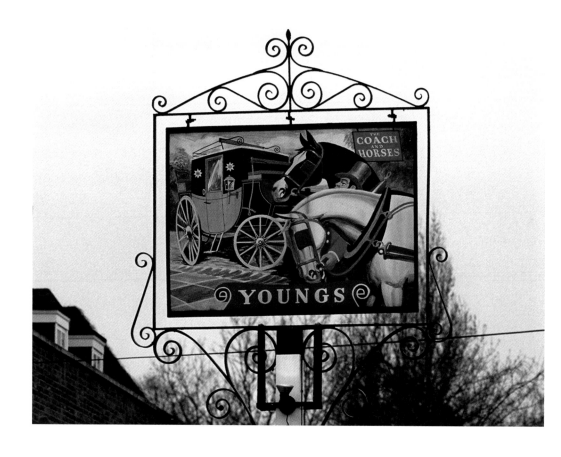

We had assumed that we could stay the night in a coaching inn, but the landlord swore at us, and said he had better ways of making a living, so we carried on to Kew.

The next day Robinson had to go to work at Barking, and I was left alone.

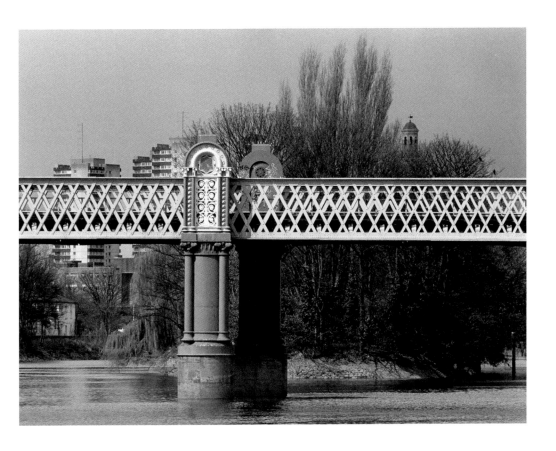

I spent the morning reading, then drifted on to Mortlake, where he joined me in the evening.

We lay down by the water's edge, and fell asleep.

UTOPIA

In the nostalgias of the electronic age — hunter-gatherer economies supported affluent, egalitarian societies saturated with understanding of inner experience and proficient in art.

Even in the Kalahari Desert, the working week seldom exceeded twenty hours, and half the population was skilled in healing, rain-making or hunting magic by means of visions and out-of-body travel in ceremonies of music, dance and trance.

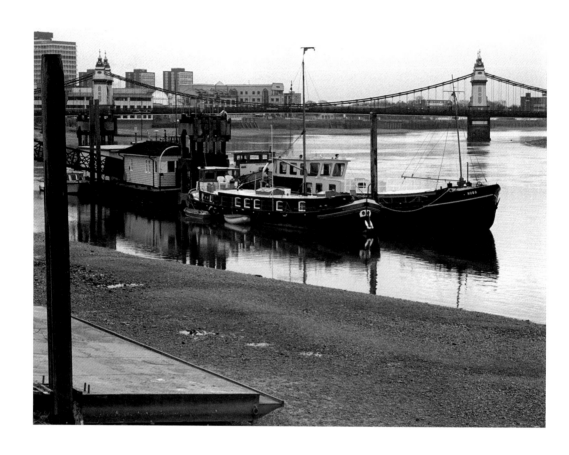

The next morning, we walked to Hammersmith, and rested outside the house of William Morris.

We remembered what we used to think of as the future: sophisticated engineering, low consumption, renewable energy, public transport; but just now London is all *waste*, without a future, its public spaces either void, or the stage sets for spectacles of nineteenth-century reaction, endlessly re-enacted for television.

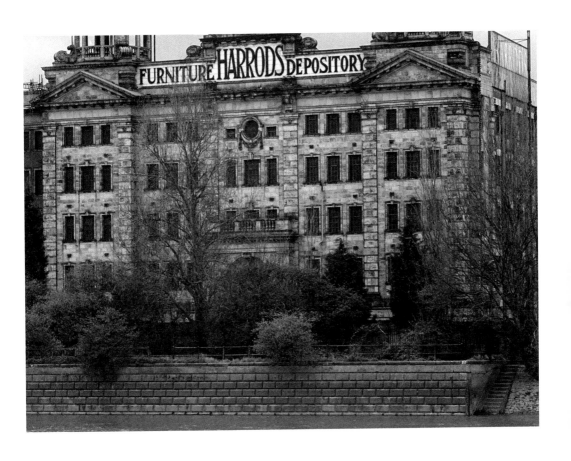

55

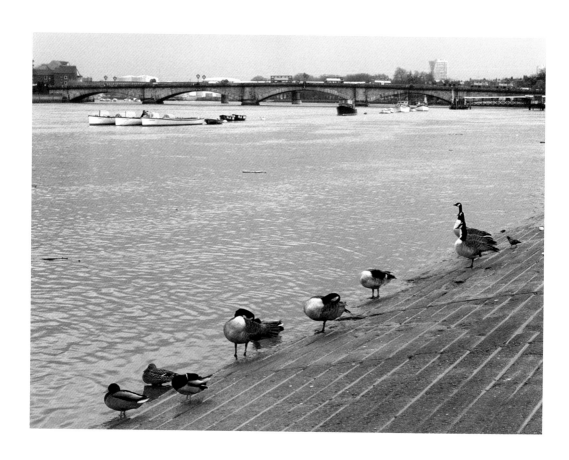

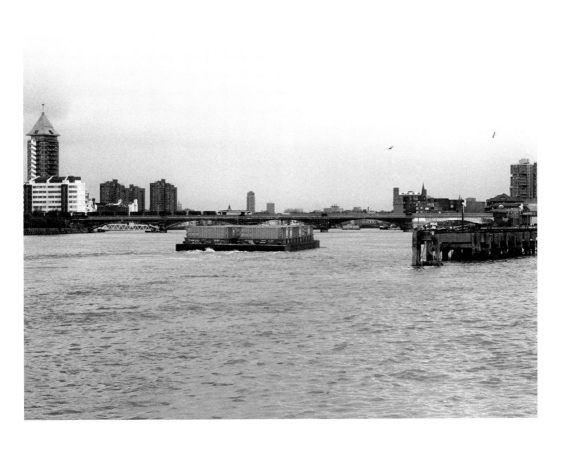

'Most of the traffic on the river now,' said Robinson, 'is rubbish on its way to landfill sites in Essex: half a million tons a year from the depots at Battersea and Wandsworth Bridge.'

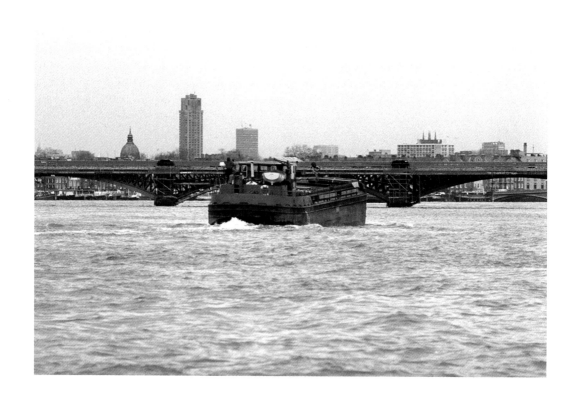

'Sometimes...' he said, at Battersea Reach, where trains that carry spent uranium cross the river at night. 'Sometimes, I see the whole city as a monument to Rimbaud.'

THE BRIDGES

'Crystal-grey skies. A strange pattern of bridges, these straight, those arched, others descending or slanting at angles to the first; and these figures recurring in the other lighted circuits of the canal, but all so long and light that the banks, loaded with domes, sink and diminish. A few of these bridges are still encumbered with hovels, others support poles, signals, frail parapets. Minor chords cross each other and slip away; ropes rise up the banks. One distinguishes a red jacket, perhaps other costumes and musical instruments. Are these popular tunes, fragments of manorial concerts, remnants of public hymns? The water is grey and blue, wide as an arm of the sea. — A white ray, falling from the height of the sky, destroys this comedy.'[6]

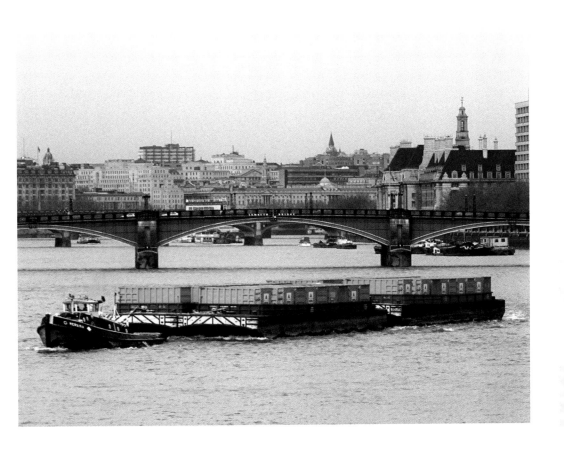

THE END OF THE FIRST EXPEDITION

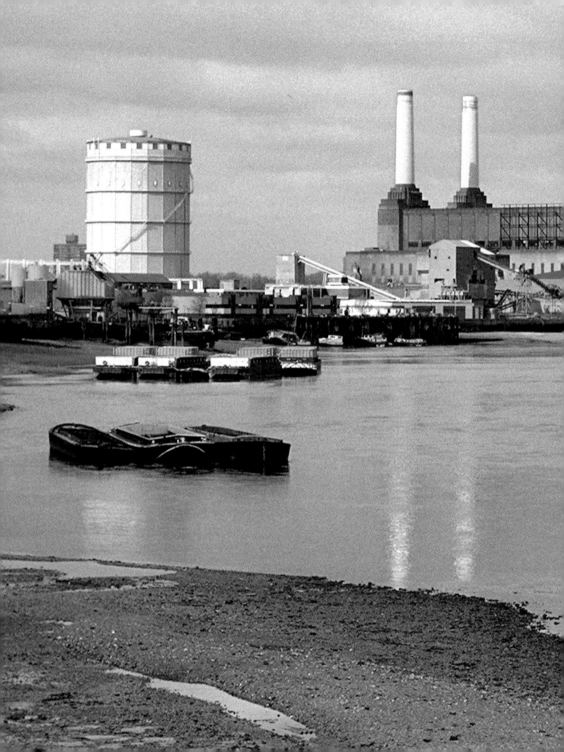

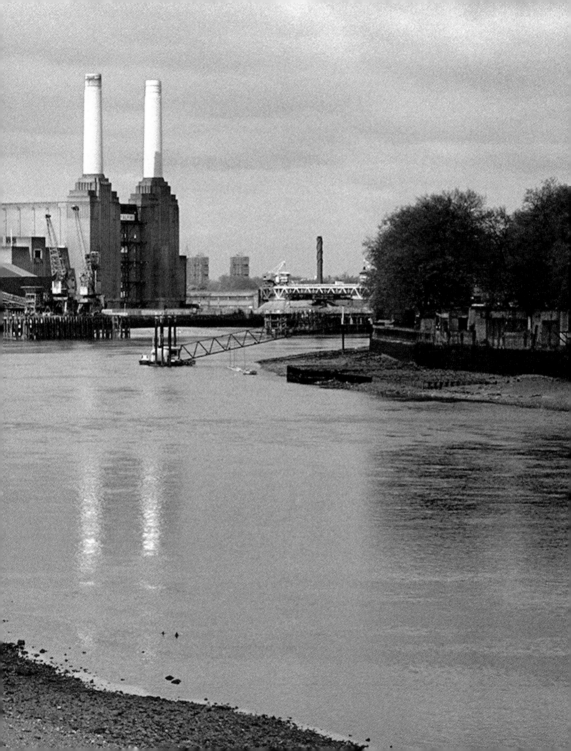

Robinson believed that, if he looked at it hard enough, he could cause the surface of the city to reveal to him the *molecular basis* of historical events, and in this way he hoped to see into the future.

In the TV news on the evening of March 31st, three opinion polls gave Labour a conclusive lead.

He had put aside six hundred and thirty pounds, the price of a night in the suite at the Savoy where Monet had lived and worked for several months when he painted his series of views of the Thames.

MAGNOLIAS

On April 6th, he took me to see the magnolias of St Mary le Strand.

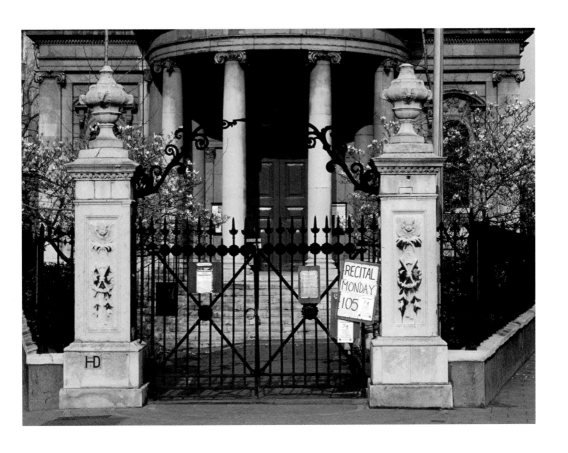

We spent the night at the Savoy and, the next morning, looked out of Monet's window.

On one side, Westminster; on the other County Hall, the former seat of London's city government, soon to be sold to a Japanese hotel consortium, and St Thomas' Hospital, under threat of closure or amalgamation.

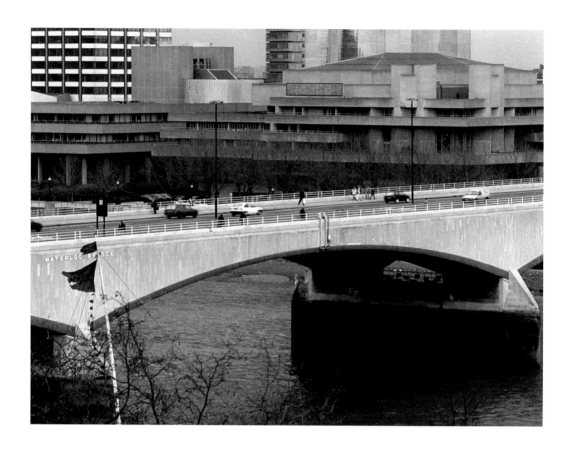

On the South Bank, the whole district was threatened with commercial reconstruction...

In the last year before the election, London had become a political issue: as far as the Tories were concerned, London's self-government should be restricted to a number of inimical local bodies, as it was in the nineteenth century, while the real power in the capital was carved up between themselves and their friends in the City.

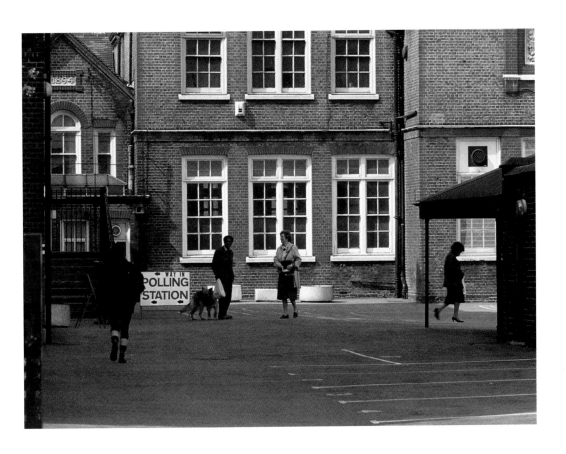

It was the evening before polling day...

Robinson voted at the school in South Lambeth Road. As a seaman, I had a postal vote, which was registered in Westminster. I expected the government would be narrowly defeated, but Robinson did not trust the opinion polls, which were in any case showing a last-minute drift away from Labour.

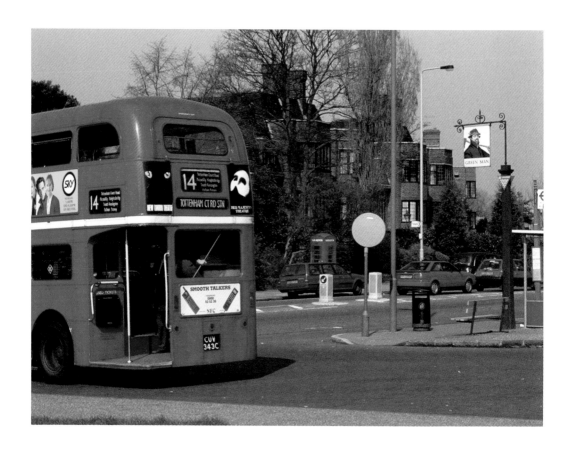

Robinson told me about his dream.

He had fallen asleep on a number 14 bus and woken up at the terminus opposite the Green Man on Putney Heath, a place I knew only from its description in *The War of the Worlds*, by H G Wells.[7]

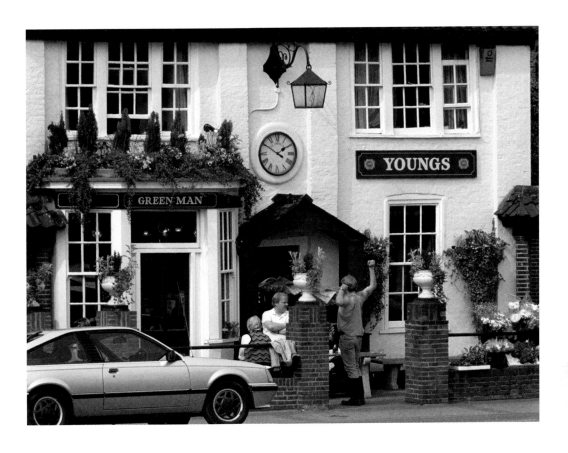

There were a number of men hanging about, mostly van drivers waiting for radio calls.

As soon as he got off the bus, he was gripped by a ghastly premonition.

In the bar, where he had tried to calm himself, a grinning stranger told him that in the eighteenth century, the Green Man stood opposite a gibbet.

He woke up, trembling with fear and foreboding, and could not sleep for the rest of the night.

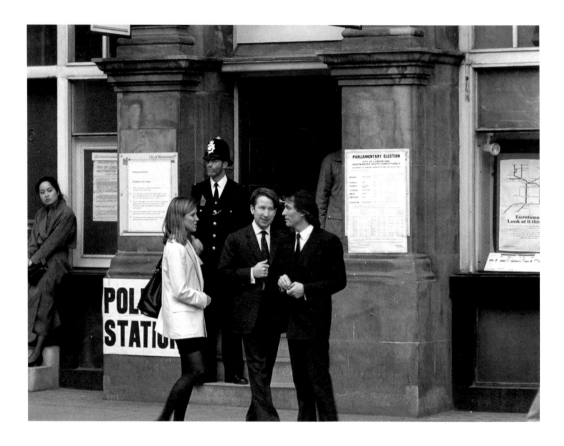

In the evening, we passed the library in Charing Cross Road, which was the polling station for the ward in which my vote was registered.

The City Council had evidently not overlooked its opportunities to influence the choice of the voters, although here too, the seat was unlikely to change hands.

At 4 a.m. we stood on the edge of the crowd in Smith Square.

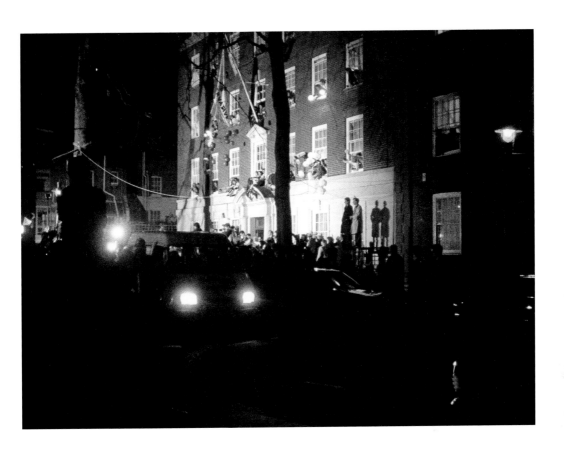

It seemed there was no longer anything a Conservative government could do to cause it to be voted out of office.

We were living in a one-party state...

It is difficult to recall the shock with which we realised our alienation from the events that were taking place in front of us.

Robinson's first reaction was one of spleen: there were, he said, no mitigating circumstances. The press, the voting system, the impropriety of Tory party funding: none of these could explain away the fact that the middle class in England had continued to vote Conservative because, in their miserable hearts, they still believed that it was in their interest to do so.

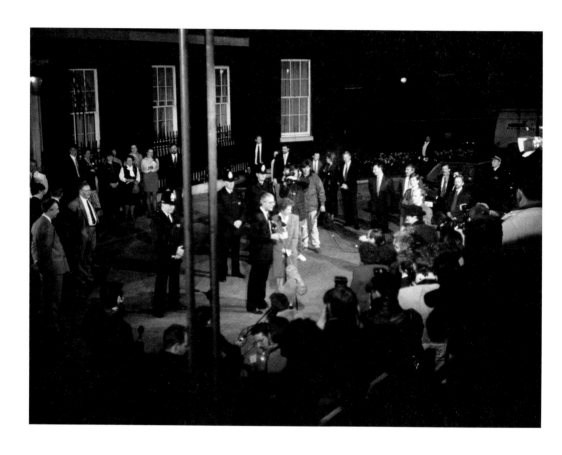

Robinson began to consider what the result would mean for him.

His flat would continue to deteriorate and its rent increase. He would be intimidated by vandalism and petty crime. The bus service would get worse. There would be more traffic and noise pollution, and an increased risk of getting knocked down crossing the road. There would be more drunks pissing in the street when he looked out of the window, and more children taking drugs on the stairs when he came home at night.

His job would be at risk, and subjected to interference. His income would decrease. He would drink more, and less well. He would be ill more often. He would die sooner.

For the old, or anyone with children, it would be much worse.

For London as a whole, there would now be no new elected metropolitan authority. The public transport system would degenerate into chaos as it was deregulated and privatised. There would be more road schemes. Hospitals would close. As the social security system was dismantled, there would be increased homelessness and crime, with the police more often carrying guns. The population would continue to decline as those who could moved away and employers followed.

As Robinson went to work along the road that leads to Basildon, he passed the print works of the *Financial Times*, which had given its editorial support to Labour in the last days of the campaign.

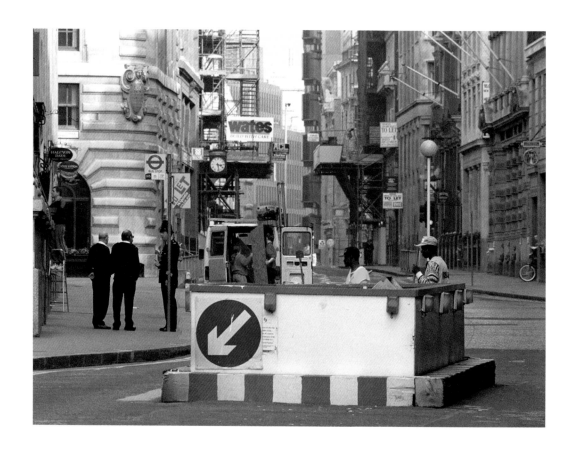

The bomb had gone off at nine thirty the previous evening. Three people were killed and 91 injured.

It was the first of two explosions that night — there was another at Staples Corner, on the North Circular Road — and it was positioned to spectacular effect, shattering windows up to half a mile away. Its target was London's insurance market.

As we waited with a group of journalists, the police brought a man out through the cordon, and he began to harangue us with conspiracy theories of all kinds.

Robinson immediately recognised this individual as a man after his own heart — he was a *Man of the Crowd*...

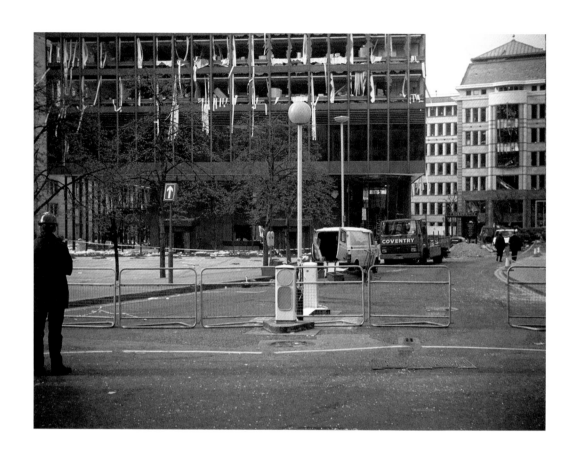

After several hours, we were escorted to the scene of the explosion.

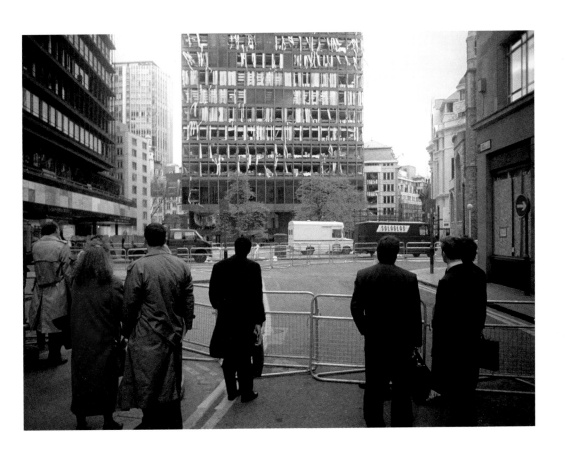

By Monday, the cordoned area had been so reduced that the public were able to come up to the end of Lime Street.

Most of the buildings in the vicinity were empty, or still being examined by structural engineers.

Lloyd's itself was hardly damaged.

On the 14th, we visited the wreckage of the B&Q at Staples Corner.

Robinson remembered that he'd once gone there to buy some bookshelves.

At the end of the morning, we went to Brent Cross to have lunch.

'If I were a poet,' said Robinson, 'this is the place I would come to to write. I feel instantly at home here.'

We caught sight of a small, intense man sitting near the fountain, reading from a book by Walter Benjamin.

Robinson embraced this man and they talked for a long time, but when he tried to call him later, he found that the number was a public telephone in a street in Cricklewood, and we never saw the man again.

At the other entrance to the park, the gateposts had stopped talking since the election.

Robinson is a materialist, his vision of the universe that of Lucretius. He brooded for weeks over the election result, unable to reconcile the re-election of the government with his understanding of nature...

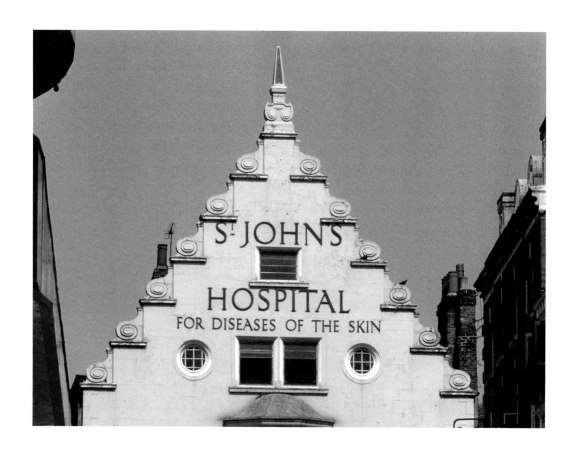

One day at the beginning of May, we found ourselves in Leicester Square.

Leicester Square is a place of particular importance to Robinson: he has *imaginatively reconstructed* it as a monument to Laurence Sterne, who visited London in 1760, following the first success of *Tristram Shandy*, and was introduced to many leading figures of the day.

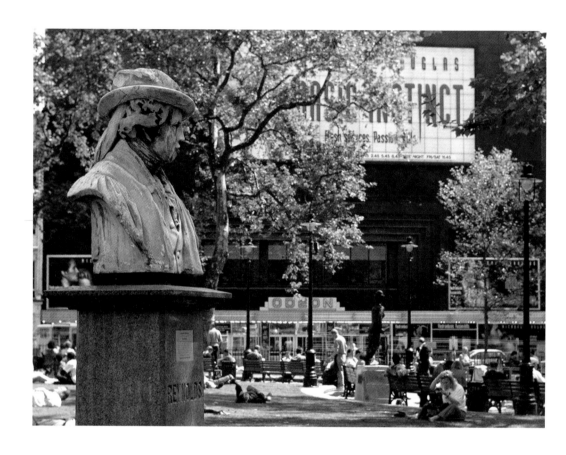

Robinson credits Sterne with the discovery of the cinema, in his description of *duration* as the *succession of ideas* 'which follow and succeed one another in our minds ... like the images in the inside of a lanthorn turned round by the heat of a candle.'[8]

He was introduced to Joshua Reynolds, who lived in the square at number 47, and Reynolds painted his portrait.

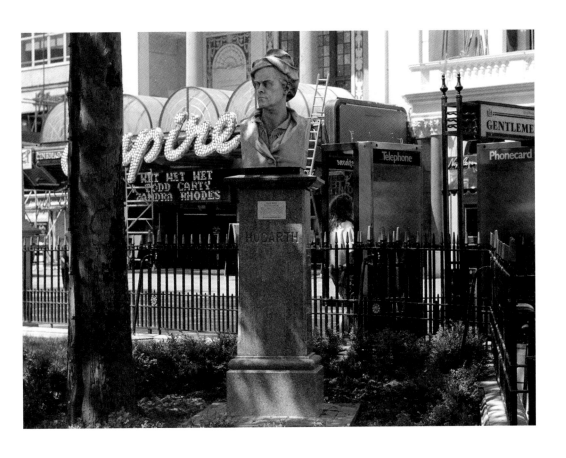

Hogarth, who lived at number 30, gave him illustrations for the frontispiece of his second edition, and for his next two volumes, which were published the following year.

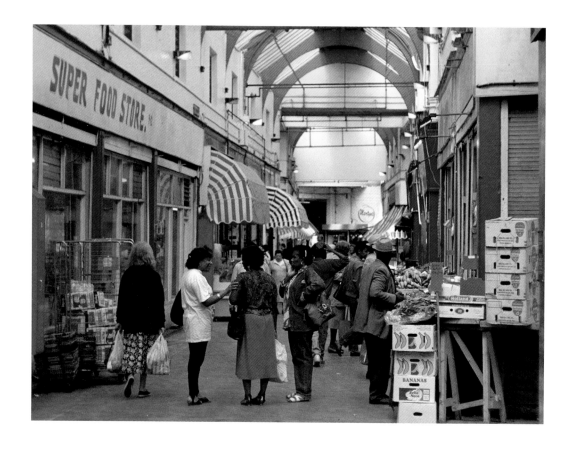

In his enthusiasms for crowds and public places, Robinson is a modernist.

Since our meeting with the writer at Brent Cross, whenever he is occupied with his literary researches, he takes the bus to Brixton Market, where he works in a cafe in one of the arcades.

He is trying to establish a connection between the Russian Formalists of the revolutionary period, with their interest in Sterne and *Tristram Shandy*, and the poet Guillaume Apollinaire, who visited Brixton in 1901.

He loves the modernity of Brixton: Electric Avenue, the Bon Marché; the railways crossing over Atlantic Road.

He told me about the passengers of the SS *Empire Windrush*, the first post-war emigrants recruited from Jamaica, who were housed in the deep shelters under Clapham Common when they first arrived.

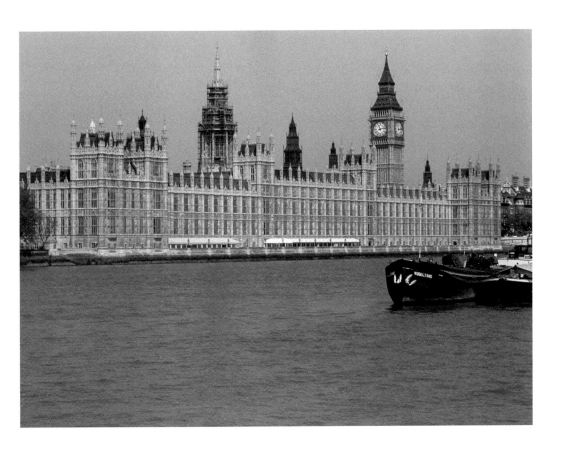

I was beginning to understand Robinson's method, which seemed to be based on a belief that English culture had been irretrievably diverted by the English reaction to the French Revolution.

His interest in Sterne and other English writers of the eighteenth century, and in the French poets who followed Baudelaire, was an attempt to rebuild the city in which he found himself *as if the nineteenth century had never happened...*

Of course, he is bound to fail: in 1800, London's population was 850,000; by 1900, it had grown to 6.5 million, the largest city ever known.

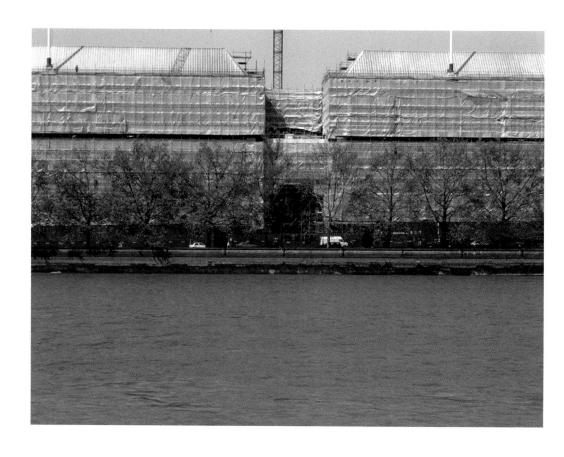

In the middle of May, it was officially acknowledged that the secret services existed, and responsibility for anti-terrorist operations was transferred from the Special Branch to MI5.

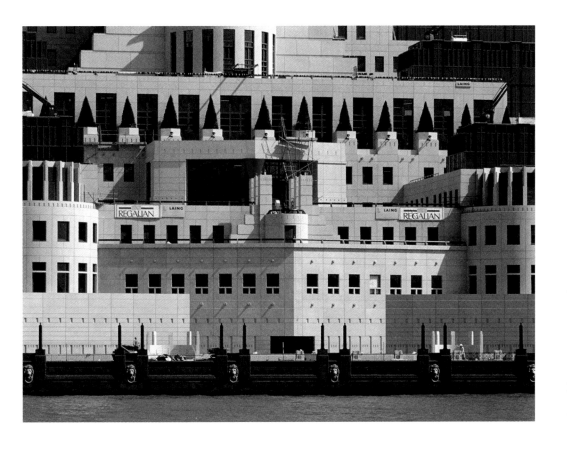

From its new headquarters on Millbank, a tunnel was being built beneath the river to that of MI6 at Vauxhall, the cost of which had by then risen to £240 million, equivalent to that of eight new general hospitals.

It seemed that every day we were faced with some new reminder of the absurdity of our circumstances.

Sunday, May 31st, was the 50th anniversary of the allied bombing raid on Cologne in 1942.

It was also the birthday of the late Sir Arthur 'Bomber' Harris, leader of Bomber Command in World War II, the instigator of the saturation bombing of civilian populations in Germany.[9]

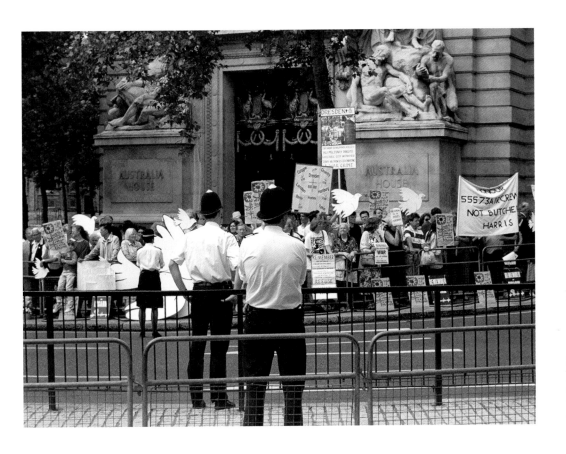

Ignoring protests, including a plea from the mayor of Cologne, the Bomber Command Association, assisted by the Ministry of Defence, had gone ahead with its plans for the statue's unveiling.

The Queen Mother was to arrive at 12 o'clock.

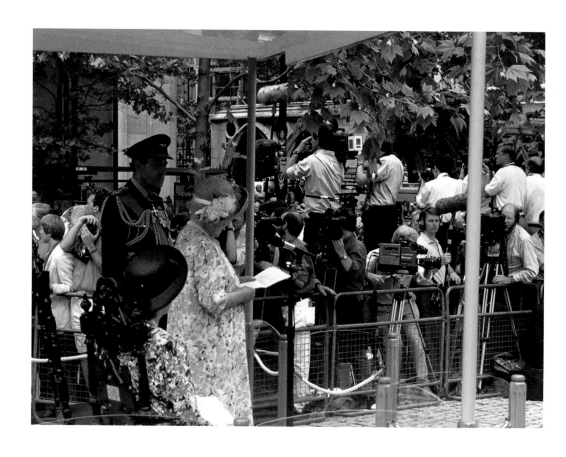

Robinson remembered her in Humphrey Jennings's film, sitting next to Kenneth Clark, the art historian, at a concert by Dame Myra Hess at the National Gallery in 1941.

As she was speaking, a group of people began shouting: 'Murderer, mass murderer!' She hesitated while police suppressed the demonstrators, then carried on.

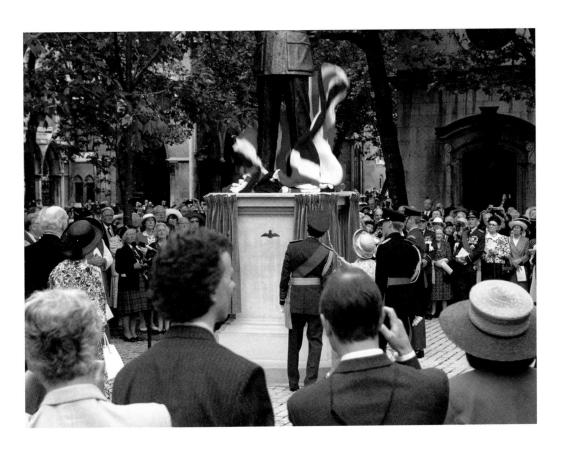

Robinson said afterwards that throughout the event, he had found it impossible to stop thinking about his father, but I have never met his father, so I didn't know what he meant.

On May 28th, the Canary Wharf development on the Isle of Dogs had been taken into administration. Robinson had up to now avoided this project, but with its failure, he decided to adopt it as a monument to Rimbaud, in memory of his wanderings in the London docks.

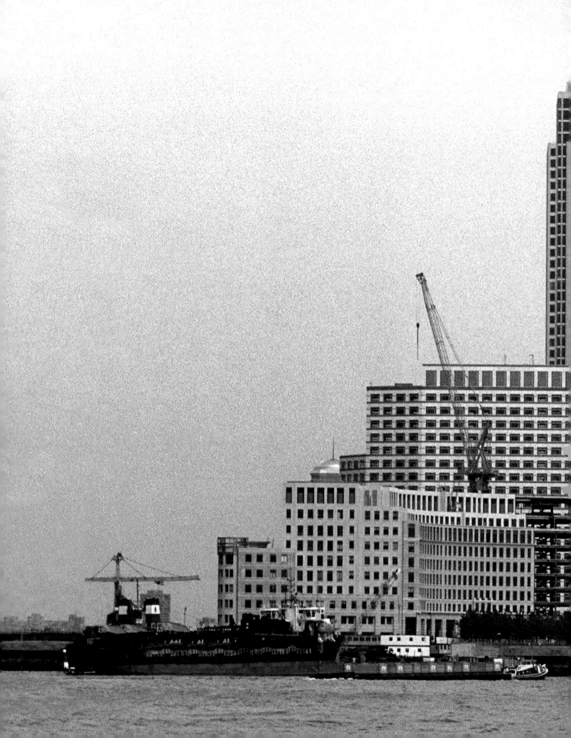

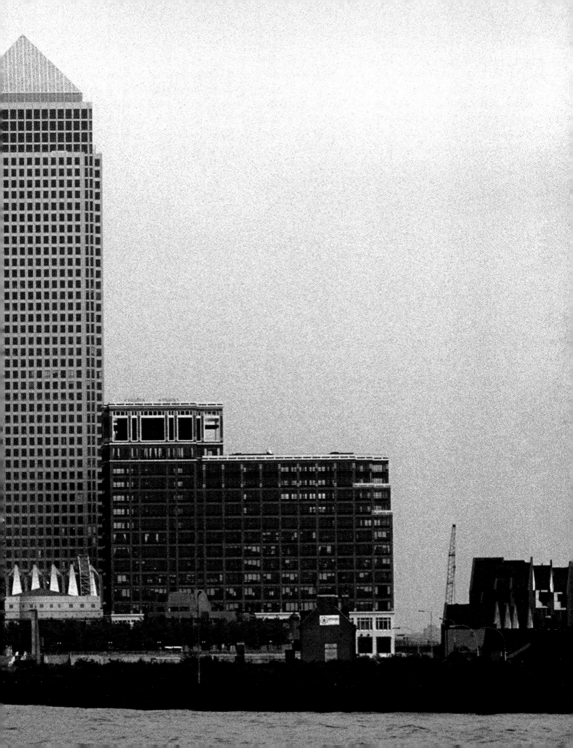

On June 4th, we passed through Leicester Square again, and found it being officially reopened by the Queen, who was to switch on a new electricity substation which had been built beneath it.

We heard that earlier, someone in the crowd had shouted, 'Pay your taxes, you scum', but there were no other incidents.

The next day, we set out on our second expedition...

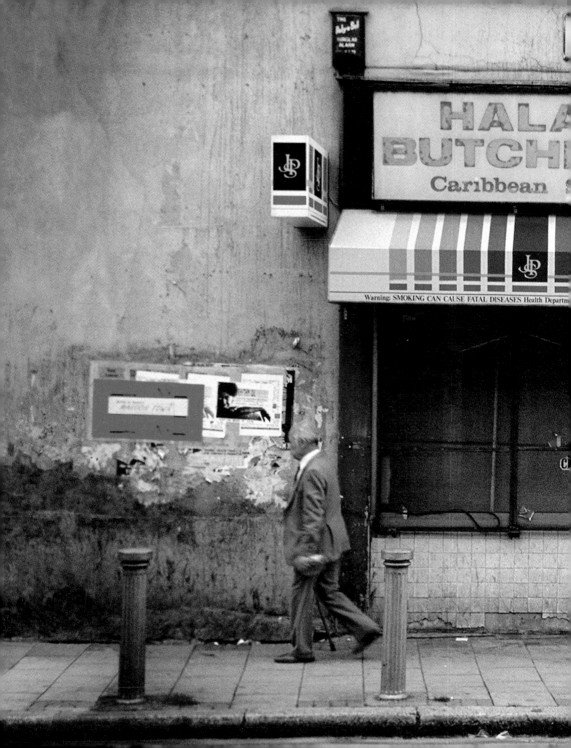

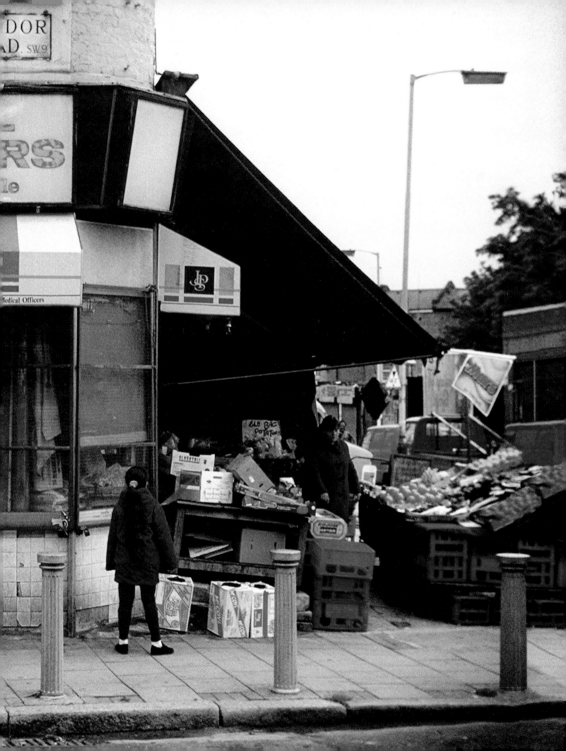

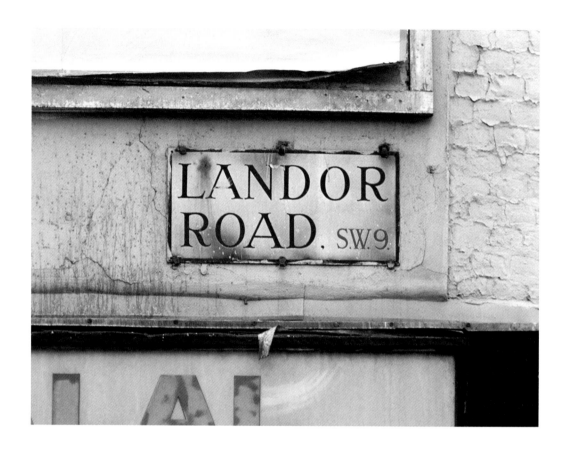

APOLLINAIRE ENAMOURED

Wilhelm Kostrowicki, a young man who later became the poet Guillaume Apollinaire, visited London in 1901.

He had met an English governess, Annie Playden, while working as a tutor in Germany. When she returned to her family's home in Clapham North, he followed, hoping to persuade her to marry him.[10]

The name of Landor was familiar to Apollinaire from the work of Edgar Allan Poe, and conjured up an image of idyllic domesticity.[11]

Annie rejected him, and emigrated to America, leaving strict instructions that he was never to be told where she had gone.

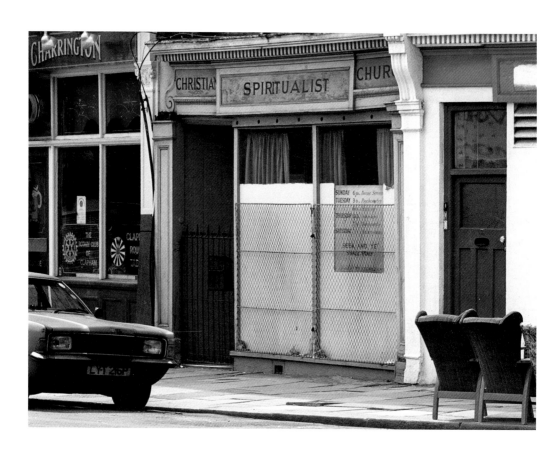

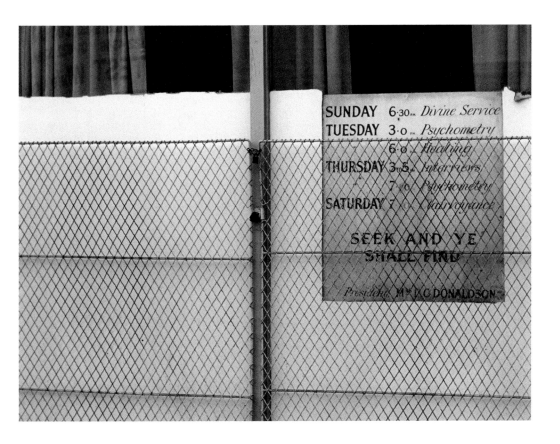

SUNDAY 6.30 ... *Divine Service*
TUESDAY 3.0 ... *Psychometry*
 6.0 ... *Healing*
THURSDAY 3.5 ... *Interviews*
 7.0 ... *Psychometry*
SATURDAY 7 ... *Clairvoyance*

SEEK AND YE
SHALL FIND

President Mrs I.C. DONALDSON

Robinson was following up a rumour that Conan Doyle had once lived in the neighbourhood, but he was unable to contact anyone who could help him.

At Stockwell, he took me to the bus garage.

I asked him where we were going, and he said he would like to walk to London Bridge, and through the City to Stoke Newington, to find the school where Edgar Allan Poe had been a pupil.

The next morning we set off again.

It was hot, and at lunchtime we stopped to rest outside the derelict hospital near the Oval station.

Robinson tires easily. He thinks there is something the matter with his liver.

Opposite St Mark's church, one of four built to commemorate the victory of Waterloo, he showed me railings made of stretchers used in air-raid shelters.

He told me how much he admired the design of the Routemaster buses, which he said was based on techniques of aircraft construction developed during World War II, and about Douglas Scott, their designer, who taught at the Central School of Art.

He told me about the London County Council, London's first metropolitan authority, which built thousands of flats all over London in the years between the two world wars.

Near the Elephant and Castle, we met a couple who had lived in a prefabricated temporary house since it was installed in 1965.

These buildings stood next to a hotel where groups of visiting schoolchildren often stayed.

It had originally been a hostel for homeless men, one of many that had been converted into hotels in the days when hotel building in London attracted government subsidy.

Now, it was rumoured to be in financial difficulties.

After twenty-seven years in the house, where they had brought up all their children, they were reluctant to leave, and had been offered nothing with comparable amenities; but as their neighbours disappeared one by one, the house was increasingly vulnerable, and they no longer felt able to leave it for more than a couple of days.

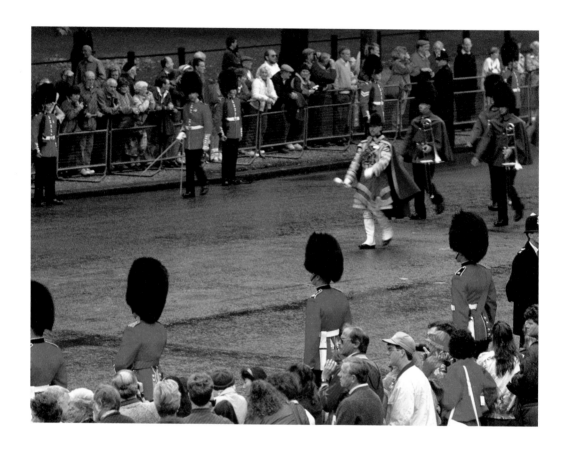

The next morning Robinson rested, and I had been offered a ticket for the ceremony of trooping the colour.

Robinson was dismissive of my interest, but I thought it unlikely that I would ever have the chance to see it again.

The custom of trooping the colour in honour of the sovereign's birthday was initiated in 1805.

The colours are those of the Household regiments of horse and foot guards, the oldest of which were formed to accompany Charles II into exile in Flanders.

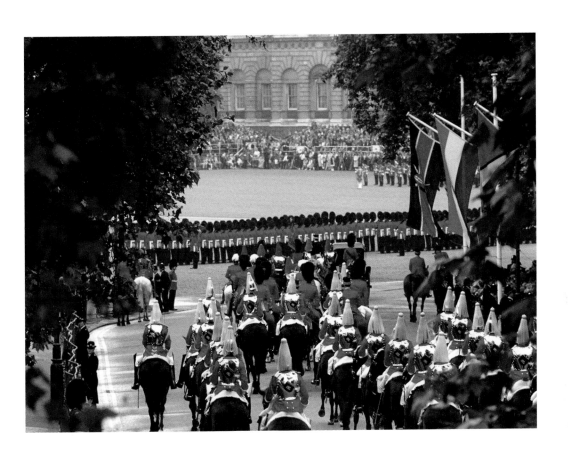

I was amazed at the contrast between the precision and splendour of the display, and the squalor of the surrounding city and its suburbs.

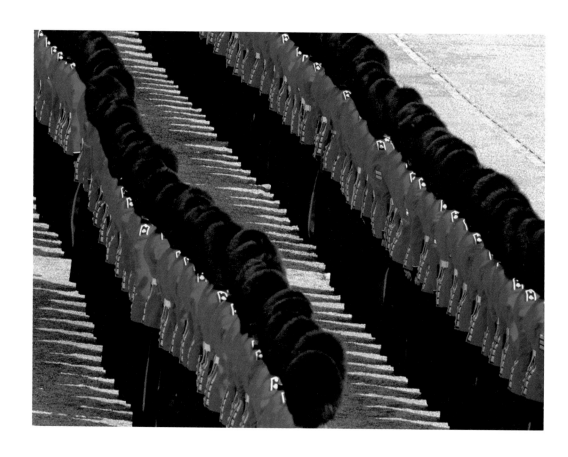

I had read that the bearskin cap was still worn in combat in the battles of the Crimean War.

Based on the caps of French grenadiers captured in 1762, the bearskin has been worn by guardsmen since Waterloo, the victory that restored reactionary governments throughout Europe.

Real fur is still used, though there have been experiments with nylon.

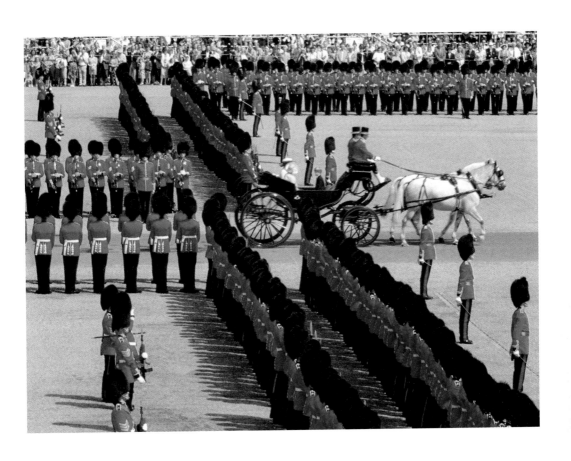

This year, there was a good deal of interest in the arrival of the Princess of Wales, following the revelations about her private life.

I was lucky to have been offered a ticket, for attendance is by invitation only, but my employment on the cruise ship had led to some unexpected introductions.

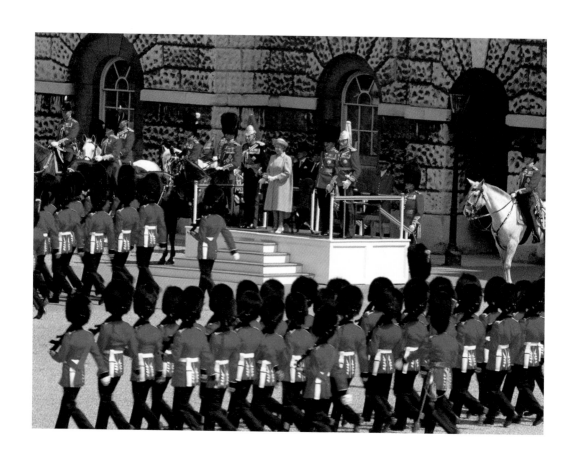

It was certainly an impressive display, and the audience was appreciative, despite the presence of large numbers of security personnel.

Two more bombs had gone off in the previous week.

I thought it odd how Londoners hardly seem to notice the monarchy and its military trappings, as I was constantly inconvenienced by their occupation of such large areas in the centre of the city.

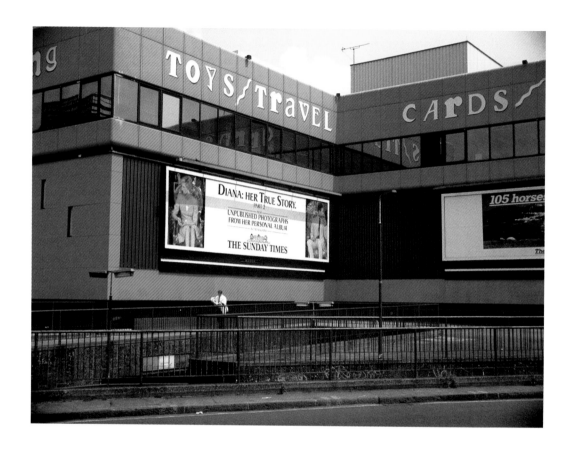

In the afternoon, we resumed our journey at the Elephant and Castle, from which buses leave for all parts of south London.

Robinson was an expert in the history of the Elephant and Castle. He knew about all the buildings and their architects, and the bureaucracy that had undermined their good intentions. He was nostalgic for the period, and would hear nothing said against it.

He told me that the Elephant did not really get its name from the Infanta of Castile, who had been engaged to Charles I, but that the association always brought to mind the king's public execution.

He showed me Goldfinger's Alexander Fleming House, newly saved from demolition.

The next day was Sunday.

On Monday we arrived at London Bridge station, in the evening rush hour...

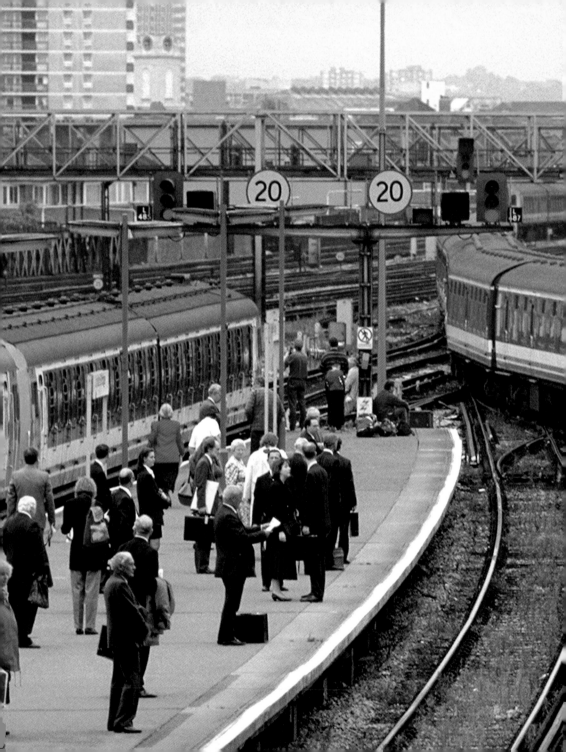

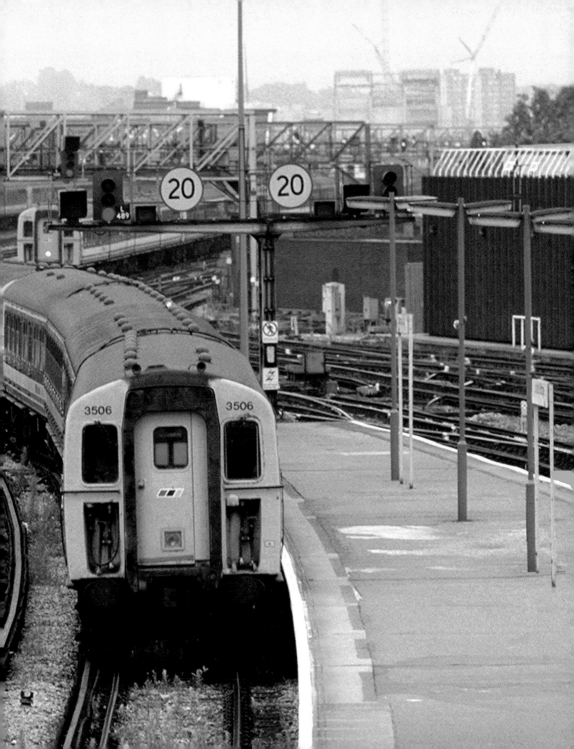

London is a colonial city. There was nothing here before the Romans came.

At 9 o'clock on Tuesday morning, we climbed up from the riverbank and stood at the north end of London Bridge...

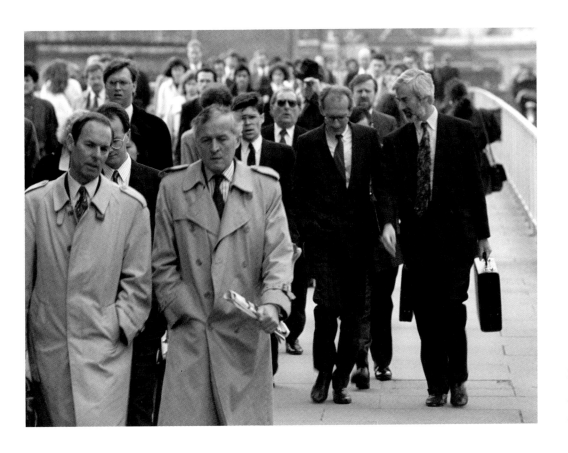

CITY

'I am an ephemeral and not too discontented citizen of a metropolis considered modern because all known taste has been evaded in the furnishings and the exterior of the houses as well as in the layout of the city. Here you would fail to detect the least trace of any monument of superstition. Morals and language are reduced to their simplest expression, at last! These millions of people, who do not even need to know each other, manage their education, business, and old age so identically that the course of their lives must be several times less long than that which mad statistics calculate for the peoples of the continent.'[12]

The boundaries of the Roman city, with its walls and gates, are approximately those of the present-day City of London, 'the City', which has become almost exclusively the preserve of international finance. The City's residential population is about 6,000, but 300,000 commute to work there daily, some over extremely long distances. Its councillors are elected by both business and residential voters, and it has its own police force, separate from the Metropolitan Police.

In the wall of the Oversea-Chinese Banking Corporation, in Cannon Street, is encased the last remaining fragment of the London Stone.

'This,' said Robinson, 'is the airborne vessel on which the magician Bladud flew to London, where he crashed on Ludgate Hill; the last stone of a circle that stood on the site of St Paul's.'

I said I thought it was a Roman milestone, but he ignored me.

'This is the stone that Jack Cade, the Kentish rebel, struck with his staff when he took possession of the city…'

Robinson could not strike the stone, but he was inspired by it, and declared Cannon Street to be a sacred site and the number 15 a sacred bus route.

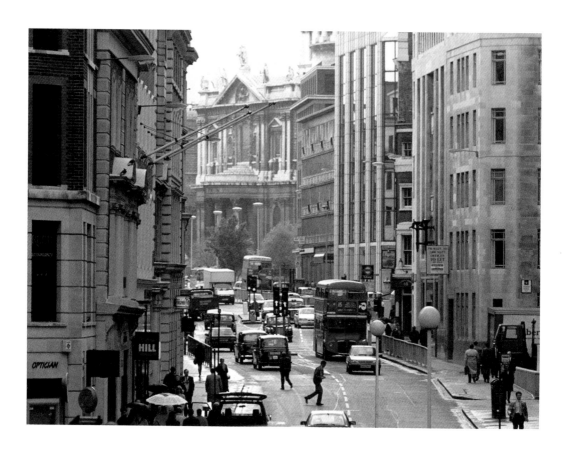

At lunchtime, it began to rain.

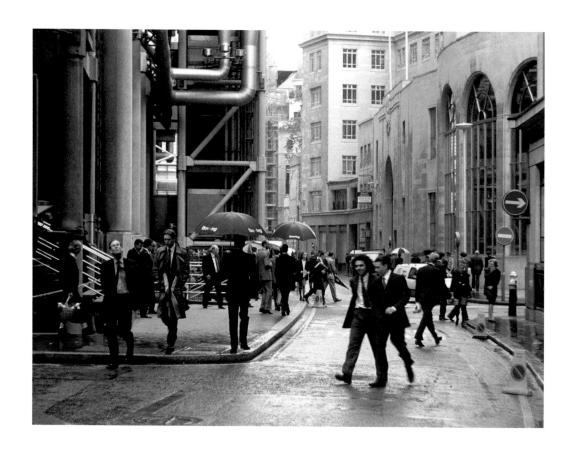

In the City, the slump had exposed the weaknesses of its institutions: Lloyd's in particular, where many Names, including forty-seven Conservative MPs, were facing either bankruptcy or heavy losses, on top of which the City bomb had left the insurance market with £800 million worth of damage, which it was difficult to distinguish from the building sites which had been so numerous just a few years before.

145

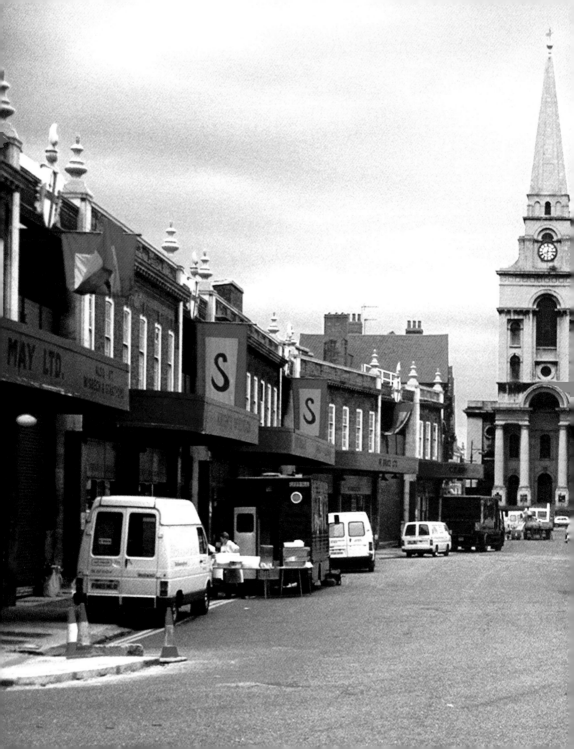

The eastward expansion of the City's territory seemed to have stalled, if only temporarily, at Spitalfields, on the east side of Bishopsgate, where two worlds co-existed awkwardly...

Robinson told me that there were 40 million square feet of empty office space in London, 16 million in the City.

On the other side of Bishopsgate, at Broadgate, a fear of redundancy was in the air.

It was beginning to look as if the City of London might start to lose its international position once the slump was over.

Beneath us, the evening rush hour was beginning.

We waited, watching people getting on the trains.

The next day we left the City and found ourselves in Arnold Circus, the centre of the Boundary Estate, in Shoreditch.

This was the first housing development undertaken by the London County Council, in 1897.

In Robinson's nostalgia, it was a fragment of a golden age, a utopia, and he contemplated it for hours.

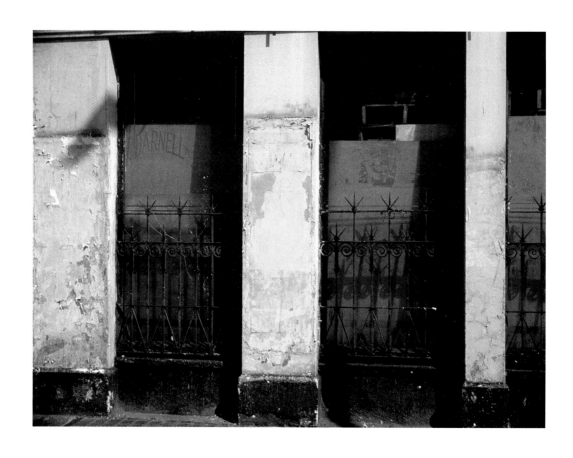

By the time we returned to our route in Kingsland Road, it was the middle of the afternoon, and we went no further that day.

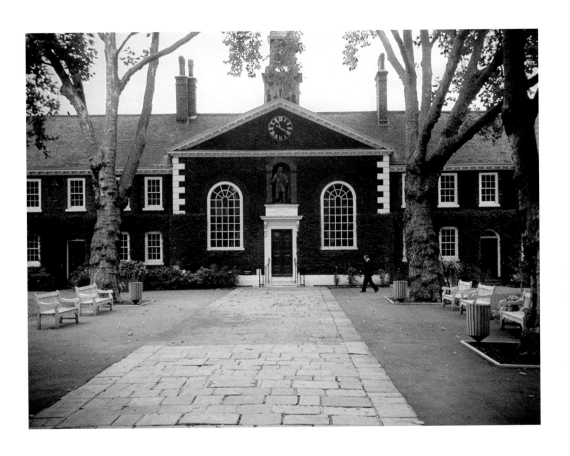

In the morning, we started at the Geffrye Museum, where we visited the Cabinet of Curiosities of John Evelyn, the seventeenth-century diarist.

Robinson sees himself as an *amateur* of similar significance, and hopes that his work, though not unprecedented, will be as influential.

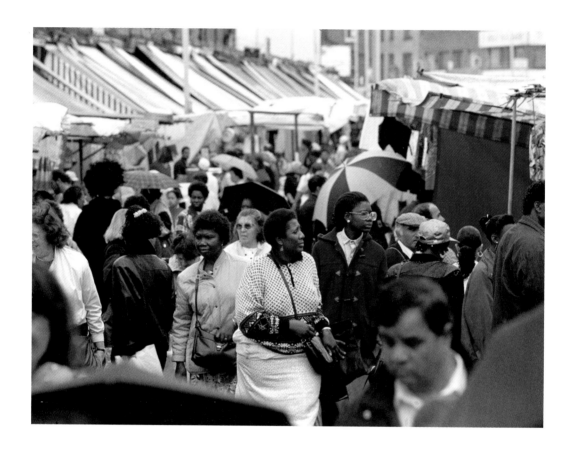

By midday we had reached Ridley Road and were nearing our destination in Stoke Newington.

As we wandered through the market he became much happier, and relaxed, and began to talk more positively about London's future.

I was not convinced by this: London has always struck me as a city full of interesting people, most of whom, like Robinson, would prefer to be elsewhere.

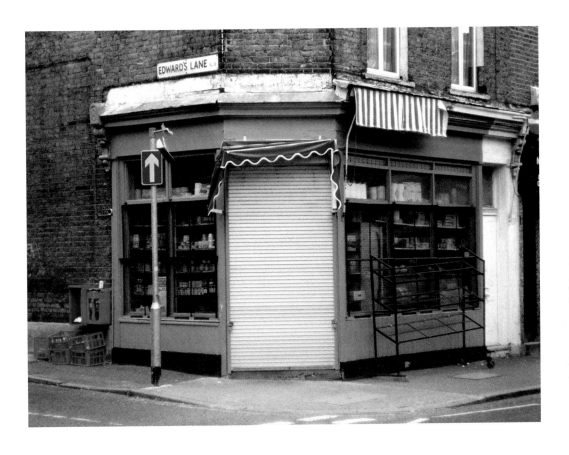

That afternoon, when we looked for the place where Poe had gone to school, we could find no trace of it, but opposite, just across the road, was the house in which Daniel Defoe had written *Robinson Crusoe*![13]

THE END OF THE SECOND EXPEDITION

Robinson was devastated by this discovery: he had gone looking for *The Man of the Crowd*, and found instead shipwreck, and the vision of Protestant isolation.

For weeks, he read long into the night, until towards the end of August he began to venture out again, with the fresh eyes of a convalescent.

At first, he went only to the library, to consult the encyclopedias.

He told me about the Metropolitan Police: in all the years he had lived in south London, he said, he had hardly ever seen them stop a motorist who was white.

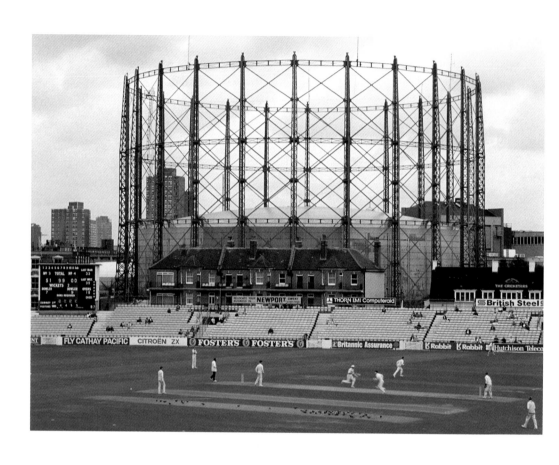

Then we went to the Oval, to look at the cricket...

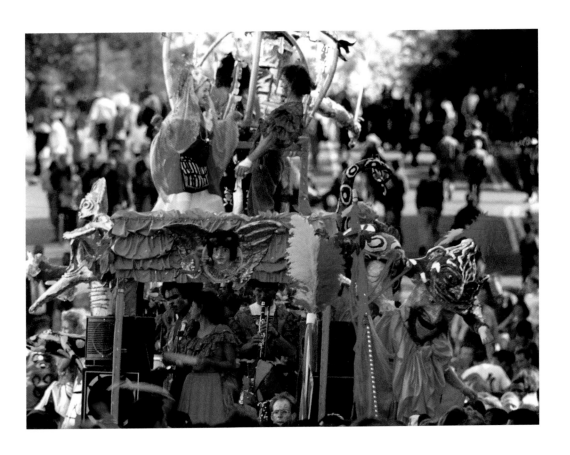

By the end of the month, he was ready for the Carnival.

He asked me if I found it strange that the largest street festival in Europe should take place in London, the most unsociable and reactionary of cities.

I said that I didn't find it strange at all, for only in the most unsociable of cities would there be a space for it, and in any case, for many people London was not at all unsociable.

I told him that the great Bartholomew Fair used to take place at the same time at the end of August. It was held for centuries at Smithfield, until banned in 1855 as 'an offence to public dignity and morals'.

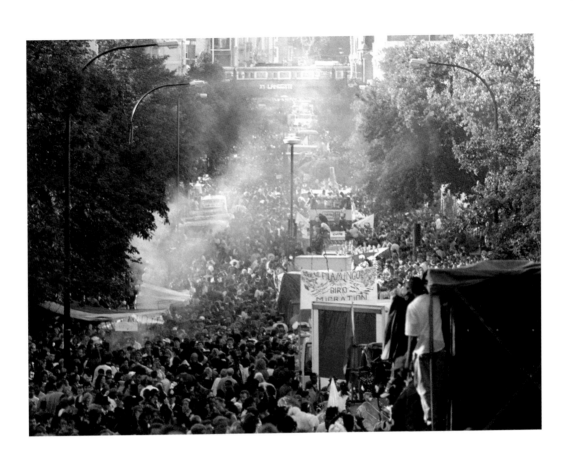

The next day we went for a walk in the West End...

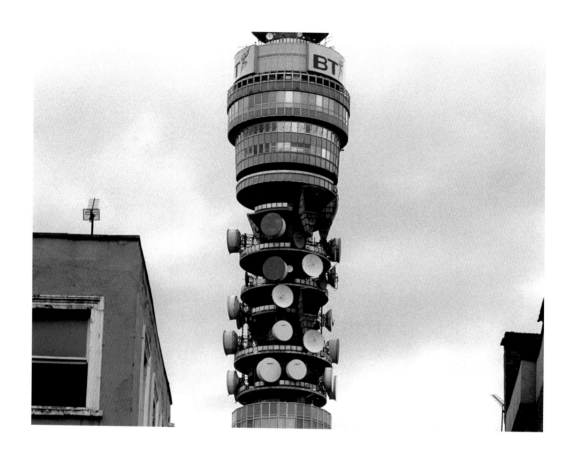

The house in which Rimbaud and Verlaine lived as lovers was demolished in 1938 to make way for a telephone exchange, where a monument to their tempestuous relationship has been erected.

Robinson is experimenting again with time travel. On September 7th, the anniversary of their arrival in London in 1872, he took me to Piccadilly Circus, where he hoped he might make some new discovery.

He told me how they improved their English by reading Poe's *Narrative of Arthur Gordon Pym*, another tale of an Atlantic sea voyage, of shipwreck and deprivation, which ends, unfinished, with the revelation that the Earth is hollow, and open at the poles...

But his discovery was in the street...

He told me that Rimbaud, in particular, found the strangeness of the Victorian metropolis conducive to work: he spent long days wandering in the docks, where drugs were easily available.

Robinson told me the story of another exile, the Russian socialist Alexander Herzen, who arrived in London at the end of August 1852 and lived initially in Trafalgar Square, in Morley's Hotel, demolished when South Africa House was built in 1935.

That evening, he read from Herzen's memoirs:

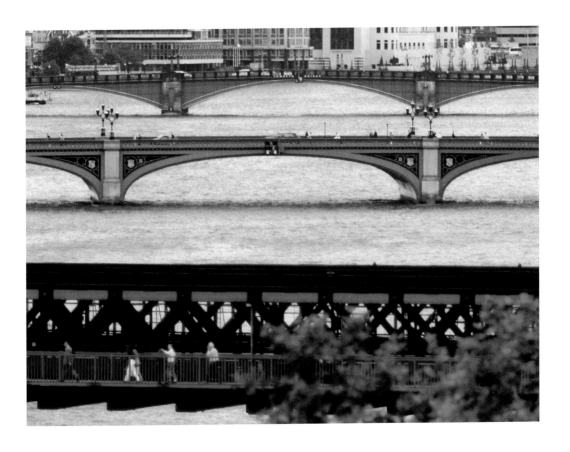

'There is no town in the world which is more adapted for training one away from people and training one into solitude than London. The manner of life, the distances, the climate, the very multitude of the population in which personality vanishes, all this together with the absence of Continental diversions conduces to the same effect. One who knows how to live alone has nothing to fear from the tedium of London. The life here, like the air here, is bad for the weak, for the frail, for one who seeks a prop outside himself, for one who seeks welcome, sympathy, attention; the moral lungs here must be as strong as the physical lungs, whose task it is to separate oxygen from the smoky fog. The masses are saved by battling for their daily bread, the commercial classes by their absorption in heaping up wealth, and all by the bustle of business; but nervous and romantic temperaments, fond of living among people, fond of intellectual sloth and of idly luxuriating in emotion, are bored to death here and fall into despair.

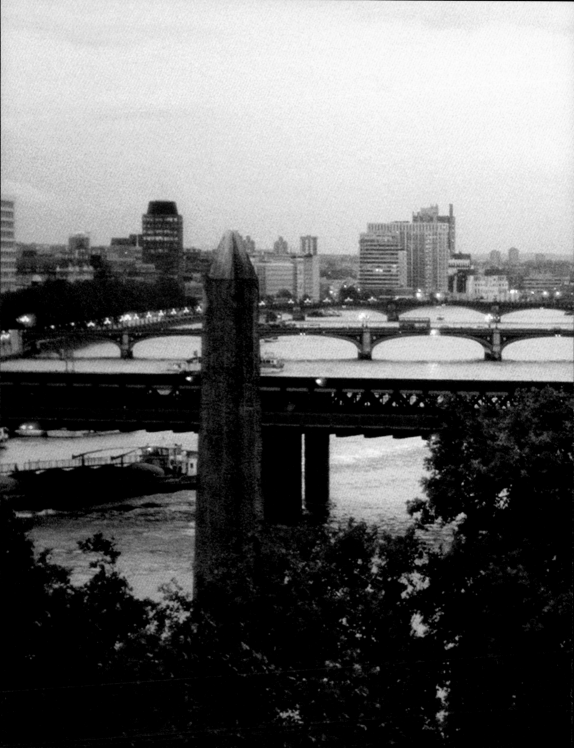

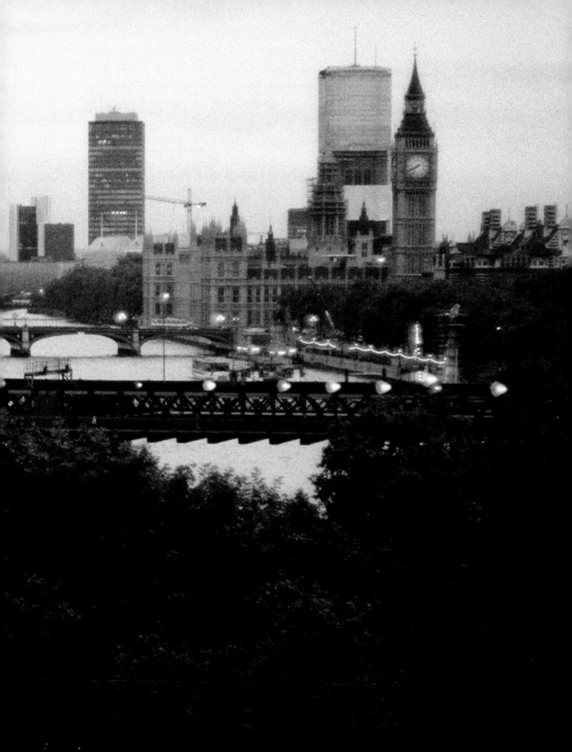

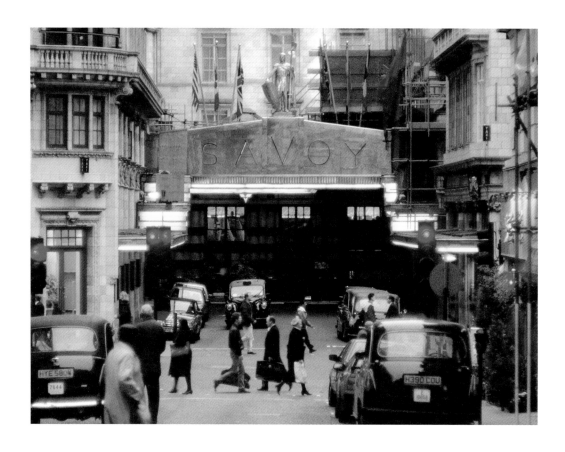

'Wandering lonely about London ... I lived through a great deal.

'In the evening, when my son had gone to bed, I usually went out for a walk; I scarcely ever went to see anyone; I read the newspapers and stared in taverns at the alien race, and lingered on the bridges across the Thames.

'I used to sit and look, and my soul would grow quieter and more peaceful. And so for all this I came to love this fearful ant-heap, where every night a hundred thousand men know not where they will lay their heads, and the police often find women and children dead of hunger beside hotels where one cannot dine for less than two pounds.'[14]

The next day, in the vicinity of St Paul's, we found ourselves in a street that neither of us knew.

In fact Robinson was convinced that the last time we had visited St Paul's, the street had not been there at all.

We heard music, then laughter, and voices; but they were talking, not in English, but in French.

We tried the door but could not get in.

Robinson had wandered all over London for years, searching for the conviviality of café life. At last, he had found it, and where else but in the City, with its ancient sanctuaries and superstitions; he had thought that nothing of this had survived its occupation by the armies of banking and finance, but now he predicted that the City would soon once again become the centre of bohemian London.

In an empty bar in Fleet Street, once the misogynist haunt of hacks now incarcerated on the Isle of Dogs, he outlined his scenario: as the City decayed, it would be reclaimed by artists, poets and musicians, the pioneers of urbanism, as the docks and markets had been twenty years before.

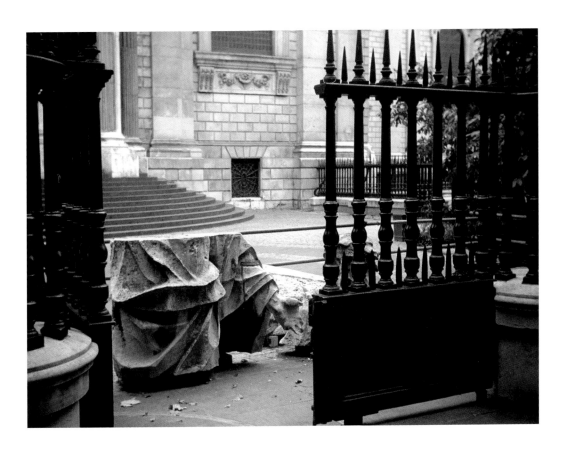

But as we passed along the north side of St Paul's he stopped, and gazed intently at a figure which had been hidden behind the railings.

He remembered how soon the artists had been priced out of the docks by developments of offices and shopping malls.

He reflected that, although the City may be in decline, it would still be many years before the Bank of England reopened as a discotheque.

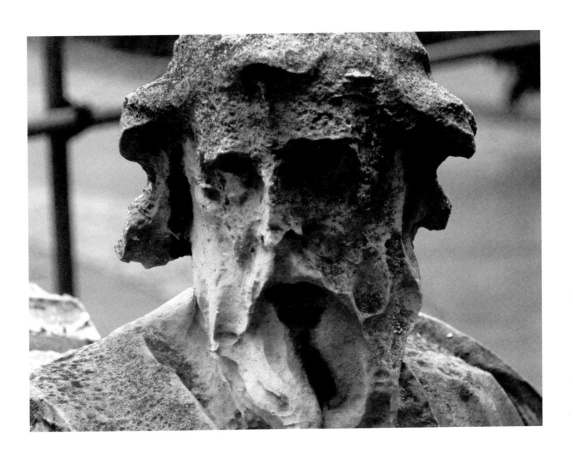

He said that London was now a city of fragments that were no longer organised around the centre, and that if we were to find modernity anywhere, it would be in the suburbs...

And so it was that we returned to the valley of the River Brent...

THE RIVER BRENT

It was a few days after the collapse of the final attempts to prop up the pound, and its withdrawal from the European Exchange Rate Mechanism.

We contemplated an impoverished, provincial future, as European influence declined.

In the new circumstances, there would be even less willingness to invest in London's future. We imagined a scenario in which the centre of the city continued to decline, and activities previously thought of as urban began to take place in the suburbs.

Robinson was optimistic: he predicted that we would discover vital, new artistic and literary activities emerging everywhere as we followed the river through the suburbs of north-west London.

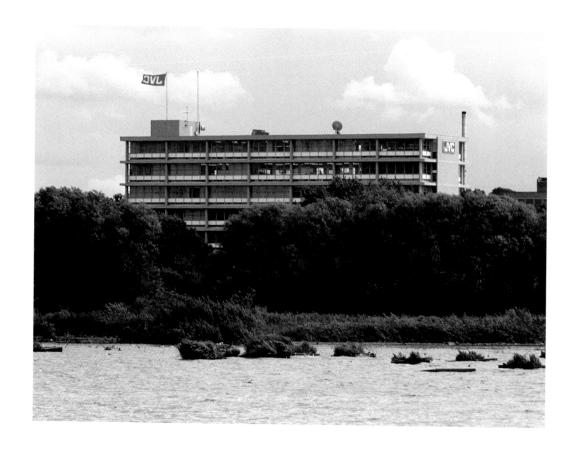

Robinson was full of plans: 'The poetry of the electronic age...' He imagined his studio overlooking the lake, and we set out with a new sense of purpose towards Brent Park, in Neasden.

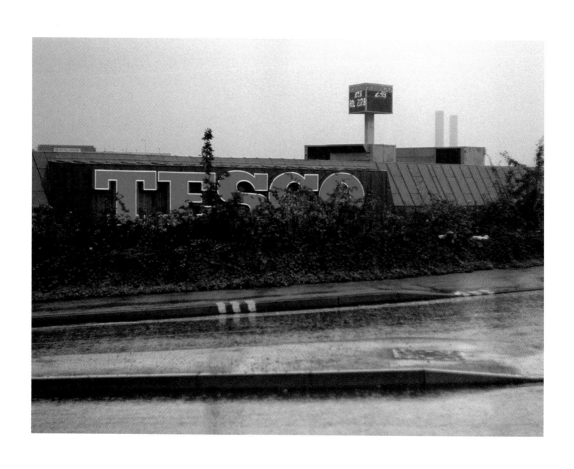

In the supermarket we found a cafe with friendly staff and pleasant, inexpensive food, but there was no sign of anyone writing poetry.

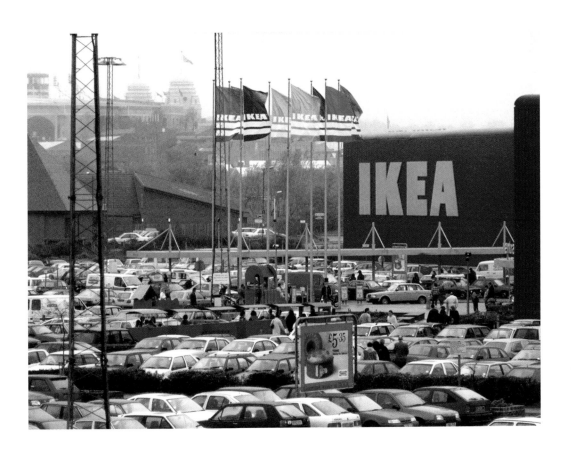

At IKEA the restaurant also seemed promising, though it had given up selling wine and beer; but the atmosphere was disappointing, tainted by the ill humour that so often accompanies questions of interior design.

We had hoped to visit the restaurant at Wembley Stadium, a design of Owen Williams, but we could not get in...

The next day, we reached Hanger Lane, and the river left the North Circular, flowing west alongside Western Avenue...

At Perivale, the river left the road, and we followed it.

As we moved away from the main thoroughfares, there were fewer people about.

We found ourselves on the edge of a large area of open space, much of it without specific use...

At the golf course (one of several), he imagined a reform of the game to make it more artistic.

Beyond Hanwell, the river is navigable, from the point at which it meets the Grand Union Canal, at the edge of the open land surrounding Osterley Park.

For all his talk about the city, I had the idea that Robinson really felt at home here...

At Boston Manor, we sat outside in the gardens, and he recalled the days he used to spend wandering in the outskirts of the city, always longing to escape.

He told me the story of Baudelaire's journey to Mauritius, and of the lifelong impression three weeks there made on him. He told me of his desire to be nomadic, and of his melancholy for all the people in the world, their ways of life and their inventions, swept away by violence and trade...

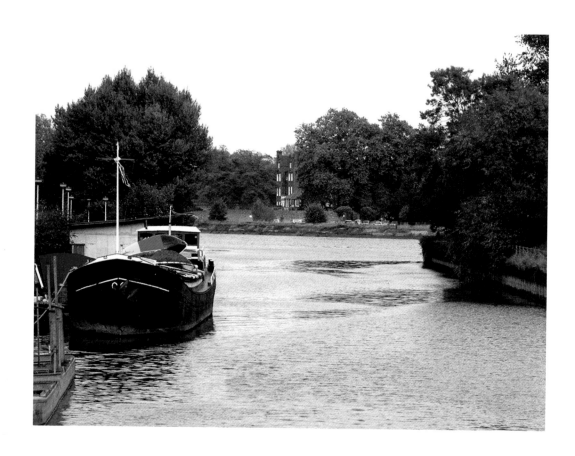

In the evening we reached Brentford Basin, where we heard music in the distance.

It was our companions Carlos and Aquiles, who were living in a houseboat there.

We stayed with them for several days, which we spent walking by the river.

The next Sunday, we returned to London.

THE END OF THE THIRD EXPEDITION

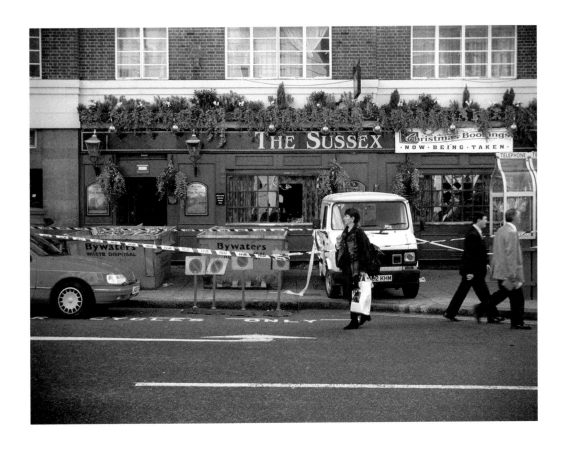

I had noticed that Robinson hardly ever goes into a pub. He says he feels threatened by the atmosphere.

On Monday, October 12th, another bomb had gone off in a pub in St Martin's Lane. Five people were injured and one of them later died. The bomb was the eighth in London within a week.

Robinson told me that he also never goes to clubs: from the Athenaeum to the most provisional of low-life nightclubs, he says, the principle of exclusivity, of fear of the mob, has poisoned social life in London...

It was the day after the announcement of the pit closures.

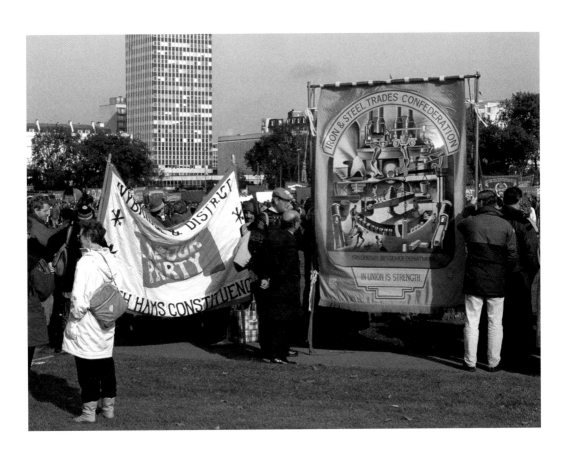

A week later, on the 21st, the miners' union held a huge rally in Hyde Park.

This event marked the beginning of a period in which the government's failures, and its bungling of the currency crisis, had created a mood of such uncertainty that it was beginning to seem possible it might not survive the winter.

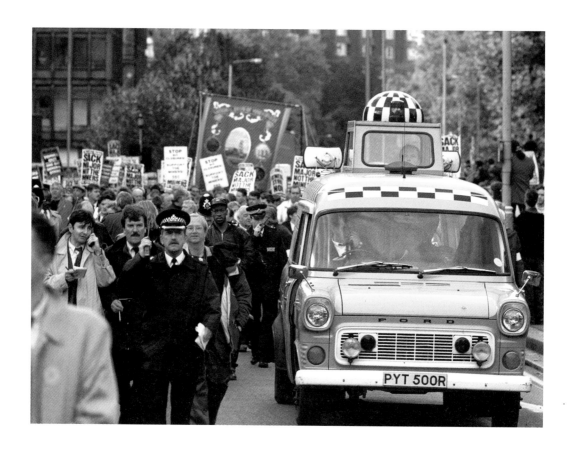

It was years since we had seen such a large turnout of the Labour movement in London, and when the rally marched through Kensington, the extent of public support for the miners was thought surprising in such a wealthy district.

In the afternoon, there was a meeting at Central Hall Westminster, to lobby Parliament in preparation for the House of Commons vote, which was addressed by miners' MPs.

At about ten thirty, the vote took place. We watched the television crews on the green opposite the House of Commons.

The Tories' backbench rebels, threatened and cajoled, had mostly given in, and the amended closure programme was passed, with Ulster Unionist support, by a majority of thirteen.

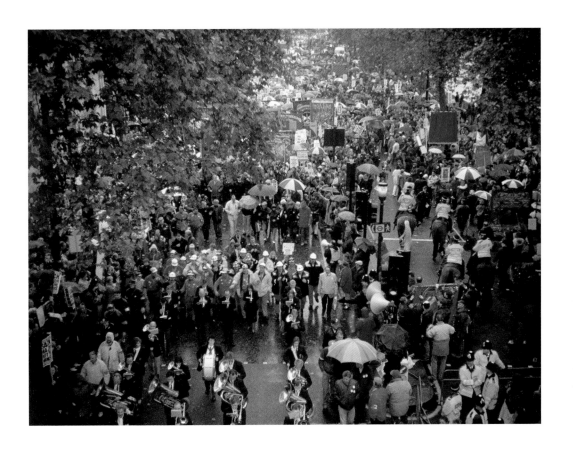

On the 25th, a massive protest march assembled on the Embankment.

Robinson and I marched with a group of his colleagues. For once, there was a feeling
of being in the majority, tempered only by the reticence of middle-class attendance at
political demonstrations, though Robinson's solidarity was genuine enough, as he
knew he would soon be facing redundancy himself.

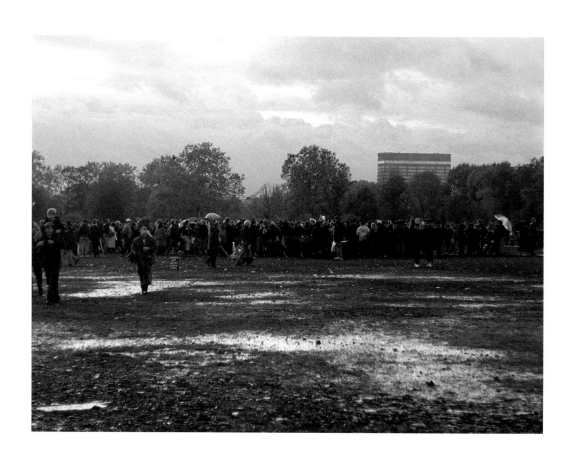

By the time we reached Hyde Park, the speakers had finished, and three hundred thousand people were dispersing.

Robinson had been talking with a colleague who lives in Southall. She invited us to spend the evening with her family, celebrating Diwali.

The next day we explored the landscapes that surround the airport.

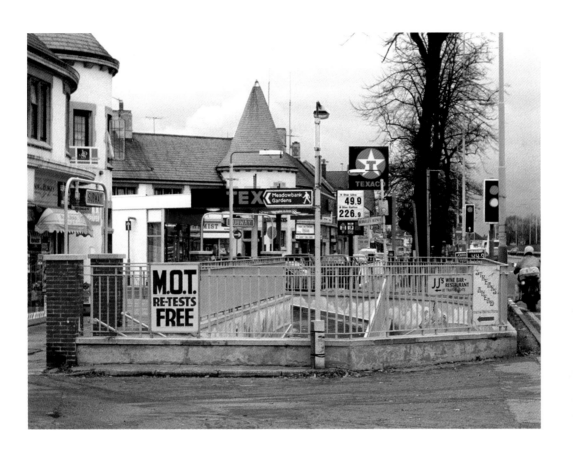

By nightfall we had reached Cranford, on the Great West Road.

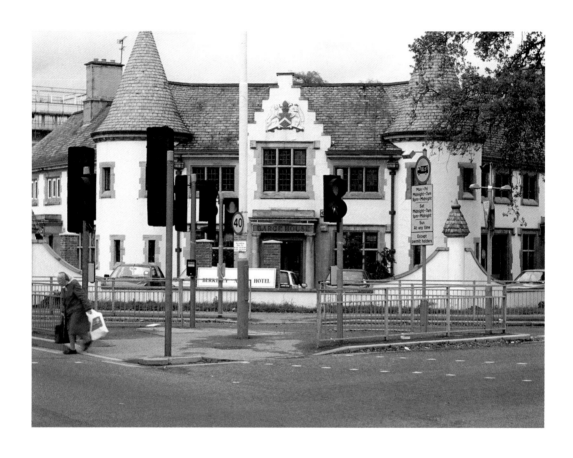

We spent the evening in a large tandoori restaurant, writing up our notes, and stayed the night in a hotel just across the road.

The next day was hot, and we spent it in the atrium of the air-conditioned Hilton.

In the late afternoon we came out and walked along the road next to the runway, until we came to Hatton Cross, where we took the underground home.

The next day, we came back again...

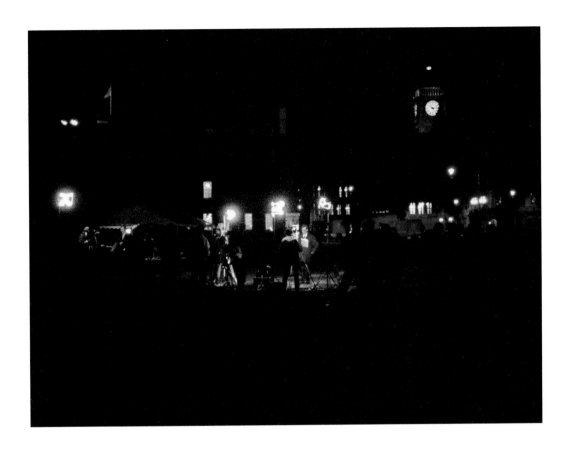

It was November 4th, the night of the first Maastricht vote, and the government faced possible defeat for the second time in two weeks, but they held on again, with a majority of three.

We watched the interviews, first with an obscure MP from Norfolk who had changed his mind at the last minute, and then with one from Staffordshire, who hadn't, but we could make no sense of either of them.

Robinson began to talk, as he often did, of leaving the country, but as always, he had no idea where to go:

ANY WHERE OUT OF THE WORLD

'Life is a hospital where every patient is obsessed by the desire of changing beds. One would like to suffer opposite the stove, another is sure he would get well beside the window.

'It always seems to me that I should be happy anywhere but where I am, and this question of moving is one that I am eternally discussing with my soul.'[15]

It was Guy Fawkes night, and we went to the bonfire in Kennington Park.

THE DAY OF THE DEAD

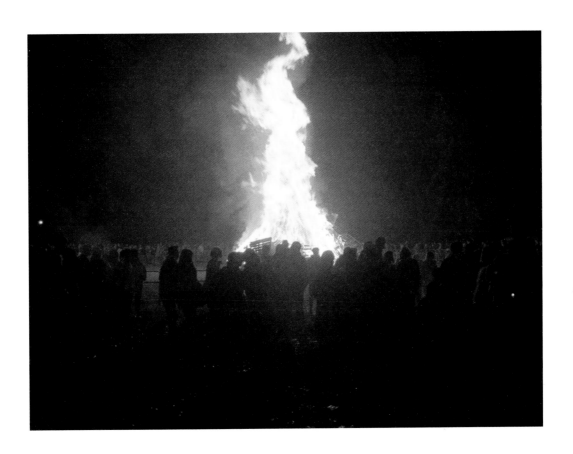

On the 11th of November, we boarded a number 11 bus and travelled east towards the City.

Robinson told me that his work was nearly over. He argued that the failure of London was rooted in the English fear of cities, a Protestant fear of popery and socialism: the fear of Europe, that had disenfranchised Londoners and undermined their society.

He denounced the anachronisms of the City, and its constitutional privileges; in Fleet Street, I had to restrain his attempts at violence towards the lord mayor, but later, when we stood on the portico of the Royal Exchange, he became quiet, and reflected:

'For Londoners, London is obscured: too thinly spread, too private for anyone to know; its social life invisible; its government abolished; its institutions at the discretion of either monarchy or state, or the City, where, at the historic centre, there is nothing but a civic void, which fills and empties daily with armies of clerks and dealers, mostly citizens of other towns.

'The true identity of London,' he said, 'is in its absence. As a city, it no longer exists. In this alone it is truly modern: London was the first metropolis to disappear.'

We walked home across Southwark Bridge, in silence.

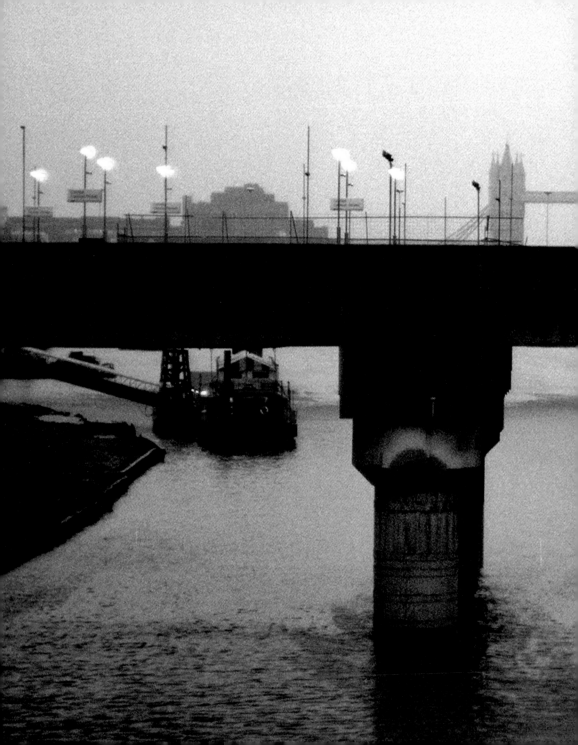

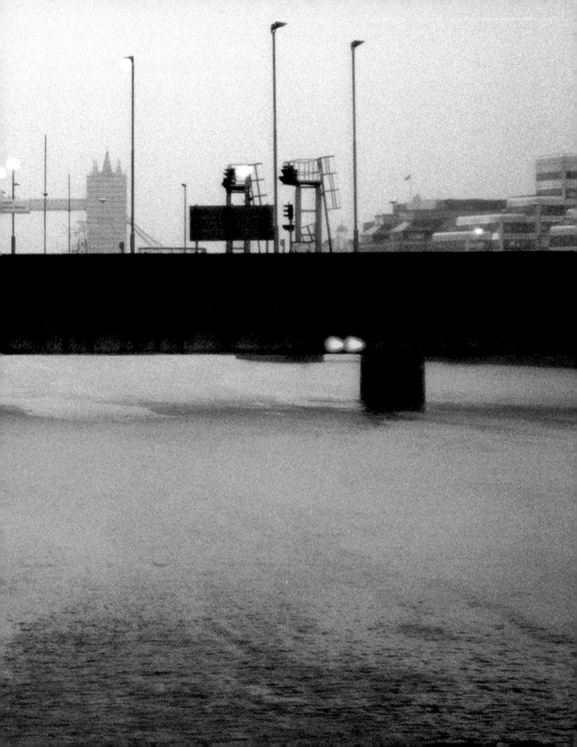

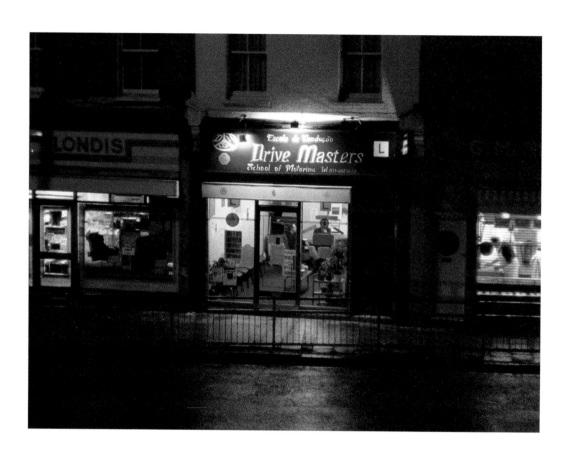

When we got back, I stood at the window…

In the nine months or so since I had returned to London, a number of changes had taken place in the street where Robinson lived.

The street itself had been designated a 'Red Route', a device to speed the flow of commuters from the suburbs to the centre.

During August, there had been a spate of shopbreaking by a group of teenage boys, so that all the shops across the road had fitted roller shutters, and at night the pavement was now lined with aluminium.

The next morning I woke at five thirty.

9 DECEMBER 1992

Afterword

London was the first film I made in 35mm and the first in colour, changes that seemed to make it possible to revive some of the preoccupations of an earlier project: in the written proposal presented to the British Film Institute in 1991, I had called it *London, or A Feeling for Nature*, the alternative title borrowed from Louis Aragon's 'A Feeling for Nature at the Buttes-Chaumont', the second part of his *Paris Peasant* (1926), the 'new kind of novel' that had encouraged my attempts at image-making ten years earlier.

In the late 1970s, having lived in London for ten years, I had decided to treat as a project what had until then been merely a habit of photographing examples of what I later came to call 'found' architecture. Like many architects, I photographed buildings that interested me, particularly any that – given the chance, which wasn't likely – I might hope to emulate. The photographs were colour transparencies and the standard of photography was not high. To begin with, the subjects were mostly examples of European modernism encountered on trips abroad, but I was drawn increasingly to more or less eccentric buildings and other structures nearer home that seemed to me to possess architectural qualities that had perhaps not been sought by, or were at least not of primary importance to, their creators. Some were industrial structures, some – assemblies of scaffolding, for example – temporary, others merely unusual, perhaps responses to complicated briefs or awkward sites.

First encounters with these structures were often accompanied by a kind of shock: a moment of conceptual transformation that I understood as a prompt to take a photograph. The photographs rarely seemed to capture their subjects' significance, though this could sometimes be conveyed in words. I discovered what I thought might be a precedent for this activity in 1920s Surrealism,[i] and in 1979 embarked on a postgraduate project, my application having enclosed a selection of 48 slides each accompanied by a short paragraph. This was a first example of a 'work' comprising images of architecture and text.

In *Paris Peasant*, Louis Aragon described his 'feeling for nature':

> I felt the great power that certain places, certain sights exercised over me, without discovering the principle of this enchantment. Some everyday objects unquestionably contained for me a part of that mystery, plunged me into that mystery. ... The way I saw it, an object became transfigured: it took on neither the allegorical aspect nor the character of the symbol, it did not so much manifest an idea as constitute that very idea. ... I acquired the habit of constantly referring the whole matter to the judgement of a kind of *frisson* which guaranteed the soundness of this tricky operation.[ii]

In his 1929 essay 'Surrealism', Walter Benjamin wrote that

> [i]t is a cardinal error to believe that, of 'Surrealist experiences', we know only the religious ecstasies or the ecstasies of drugs. ... [T]he true, creative overcoming of religious illumination certainly does not lie in narcotics. It resides in a *profane illumination*, a materialistic, anthropological inspiration, to which hashish, opium or whatever else can give an introductory lesson.[iii]

Benjamin's 'Hashish in Marseille'[iv] dates from the previous year.

It seems strange that so little has been written about the relationship between such altered subjectivities and photographic media.[v] Perhaps it was hardly surprising that my project soon lost momentum, partly because *profane illumination* is difficult to sustain, but also because although by then I was familiar with the phenomenon, I lacked technique. I had also hoped to record movement through space, but was discouraged by the low resolution of 16mm film and 625-line video. Architectural images conventionally rely on detail to create an illusion of depth, so that architectural photographers have traditionally favoured large formats. I was used to 35mm colour slides, not so large, but not subject to the generational loss that occurs when a print is made from a negative. A 16mm film frame has an emulsion area of about 77 square millimetres, compared to the 864 square millimetres of a 35mm slide or negative. Eventually I made a 21-minute monochrome 16mm film that combined moving camera footage with fictional narration. Later in the 1980s, I made four more similar films, but in achieving a level of practice seemed to have set aside an initial idea that having

explored 'found' architecture and peripheral landscapes, I might then reveal a similar strangeness in more familiar spaces nearer to or in city centres.

The last three of these films were photographed on journeys, the longest of which was to Rome. It was called *The End*, partly because its ending attempts to mimic the last few seconds of its first-person narrator's consciousness, and partly as a kind of joke to acknowledge that, while a film conventionally has a beginning and an end, seen as an object – 200 metres of film – it has two ends, one of which is the beginning. *The End* was completed in 1986; about two years later, one Saturday afternoon in a bookshop, I noticed a paperback with the title *Ends and Beginnings*, a selection from the later parts of Alexander Herzen's memoirs *My Past and Thoughts*, towards the end of which is the chapter 'The Fogs of London', which begins:

> When at daybreak on the 25th of August, 1852, I passed along a wet plank on to the shore of England and looked at its dirty white promontories, I was very far from imagining that years would pass before I should leave those chalk cliffs.[vi]

Herzen had left Russia in 1847 for Paris, witnessing and participating in the revolutions of 1848. He stayed in England until 1864, in London, establishing the Free Russian Press and *The Bell*, distributed clandestinely in Russia. A few pages further on, I read the passage that is quoted in *London* – and, I noticed later, in Humphrey Jennings's *Pandaemonium* – which seemed to me to chime very well with experience of London in the 1980s, especially when one had just returned there from mainland Europe.[vii]

By 1989 I was keen to make a longer film. The 'journey' films had been photographed by going away for a month or so at the end of summer. A longer film would require a longer period of cinematography: I had never found London an easy camera subject, especially at ground level, and there was the problem of 'horror of home', but I knew it would be difficult to go away for longer than a couple of months. Then one evening I went to see Chris Marker and Pierre Lhomme's *Le Joli Mai*, which begins with a series of long-focal-length views over Paris, and began to think I might risk a film about the city in which I lived. In the autumn of 1989, the political atmosphere seemed to be changing.

The project was developed with support from the BFI Production Board, and commissioned by it in mid-1991 with Keith Griffiths as producer. Ben Gibson, head of BFI Production, had asked if I might make the film in colour. For a while I thought some reels might be colour and some black and white, like Warhol's *The Chelsea Girls*, but having looked into the implications of this decided to commit to colour.[viii] In Trafalgar Square one afternoon in May 1990, I noticed a man hand-holding what looked like a giant Bolex cine camera. Between his takes I asked him what it was. He looked me in the eye and said 'grosse secret'. I thought he might be German, perhaps from the former DDR, but 'Sekret' is German for 'secretion', not 'secret', so perhaps he was speaking French. The camera must have been either an Éclair Caméflex or a Konvas, a

very similar camera produced in Russia from the 1950s, but whatever it was it alerted me to the possibility of making our film in 35mm. Some time later, I saw Cornel Lucas's famous photograph of British newsreel camera crews arrayed en masse at Epsom in 1952, in which there are several cameras resembling the one I had seen in Trafalgar Square that I subsequently identified as Caméflexes. The Caméflex is a lightweight 35mm camera first produced in 1947, designed by André Coutant and Jacques Mathot to be comfortably hand-held, with most of the weight supported on one's shoulder. Much of the *nouvelle vague* was photographed with this camera, including the 35mm material in *Le Joli Mai*, and one can be seen in the opening minutes of Alain Resnais's *Toute la mémoire du monde*.

Keith and I considered the cost and reasoned that if I were prudent with the stock, it would be quite feasible to make the film in 35mm. We acquired a Caméflex and a set of prime lenses through the agency of camera engineer Alex Georgiou, who showed me how to load the magazines, quite tricky in the dark, and recommended using two 12-volt cash register batteries to power the 24-volt motor. The camera was in good condition and had probably been used initially by the Navy to film gunnery tests; a Caméflex appears in *Operation Hurricane*, a Central Office of Information film about the 1952 British atomic bomb test in the Monte Bello islands. I auditioned two colour negative stocks, one by Agfa balanced for tungsten light that needed a filter in daylight, and Eastman 5245, a daylight stock, then relatively new, rated at ISO 50. I was seeking to emulate the contrast and colour saturation of three-strip Technicolor, or at least Kodachrome, an 'amateur' reversal stock then available as 8mm and 16mm cine and 35mm slide film. Someone at Kodak told me that the first colour features made in India had been photographed on 1000-foot rolls of Kodachrome slide film, but there was no longer a print stock that suited it. It seemed that Eastman 5245 was as close as we would get, and the decision was confirmed by the footage of the 'Montaigne School of English',[ix] in which the wood grain pattern and the bright red and yellow paint stood out very well (red and yellow being Eastman-Kodak colours). It seemed to me that with this combination of camera and film stock, a degree of *materialistic inspiration* might be possible.

Although the camera was chosen partly for the ease with which it could be hand-held, most of the footage in the completed film was made with it mounted on a tripod. I had bought a large soft bag with a shoulder strap in which we kept the camera, two magazines and all but the longest of the lenses; the tripod head in its case weighed more than the loaded camera, and the legs were cumbersome, but when working on my own I could carry all the equipment for about a mile. Most of the time there were two of us. On two days of the week, Julie Norris and I would leave home at about eight thirty with our infant son to take him to a nursery in Covent Garden. If there were rushes to view we would go on to the lab in Wardour Street, then to the locations of the day. These were either topical – the sites of unexpected or planned events, some requiring permission – or places on one of several 'journeys': the proposal for the film had listed sixteen of these, of which only three were explicitly undertaken, though there are fragments of others. We would always stop for lunch – Julie was expecting our second

child – and at five thirty would be back at the nursery, so the working day was fairly short. I would sometimes go out with other companions or on my own at the weekend or in the evening, and in late September a roster of friends took over Julie's role until we stopped in November.

The equipment would almost fit in the luggage space beneath the stairs of a Routemaster, but it was a lot to ask of bus conductors, and after the first few days we reverted to the car. It was surprisingly easy to park in central London provided one had a good supply of change, but we often had to walk some distance to the locations. Having invested the effort to park, walk and set up, we often stayed longer than we had intended, waiting for arrangements of people and traffic, making images with different lenses and noticing new views. This influenced the look of the film.

We began editing in late November in a small room off the stairs to Keith's office, selecting takes and arranging them in what gradually became their final order: largely chronological, the major exception being the arrival of the cruise ship at the beginning of the film, which actually occurred in April. At the end of February the assembly edit was three hours long. In March the production moved to a cutting room at the BFI, Larry Sider joined as editor and sound designer, and by the middle of April, the picture had been cut to 86 minutes. Larry began work on the sound and I started writing narration. I was used to writing with the picture at a Steenbeck, but we only had one and Larry was more expensive than I was, so during the day I wrote blind and only worked on the machine after he had gone home. In this way, we progressed to the point of recording Paul's narration on 8 and 9 September, and the film was finally completed in January 1994, just in time to be subtitled for the Berlin Film Festival.

*

At its first public screening the young man hosting the Q&A began by asking: 'Why would anyone make a film like that?' I wasn't sure whether this was a simple enquiry or a challenge, and if the latter, whether it was provoked by the film's form or its attitude to its subject. Generally, however, it was very well received and we returned to London with positive reviews. When the film opened there in June it was surprisingly popular, and played in the West End until September.

The character Robinson[x] was devised to enable the film to address ideas and thoughts one might entertain but would perhaps not wholeheartedly endorse. He was similarly deployed in two later films, *Robinson in Space* (1997) and *Robinson in Ruins* (2010). Towards the end of *London*, he seems to have identified the city's 'problem', declaring that 'the true identity of London is in its absence'.[xi] I had only a vague idea what he might mean by this, but had often thought that London is unusual in that it frustrates attempts to discern a coherent set of characteristics that one might see as an 'identity' – unlike mainland European capitals such as Paris, Rome or Berlin.[xii] The film had set out to address this as a deficiency, but perhaps one can see it as something to be valued.

i See Bernard Tschumi, 'Architecture and its double' and Roger Cardinal, 'Soluble City: The surrealist perception of Paris', *Architectural Design* 48 (2-3) (1978) *Surrealism and Architecture*, 111-116, 143-149, and the catalogue of the 1978 exhibition *Dada and Surrealism Reviewed* at the Hayward Gallery, London.

ii Louis Aragon, *Paris Peasant* (Boston: Exact Change, 1994), 113, 114, 115.

iii Walter Benjamin, 'Surrealism: the Last Snapshot of the European Intelligentsia', *One-Way Street and Other Writings*, tr. Edmund Jephcott and Kingsley Shorter (London: NLB, 1979), 225-239, at 227.

iv Walter Benjamin, 'Hashish in Marseille', *One-Way Street and Other Writings*, tr. J A Underwood (London: Penguin, 2009), 116-124.

v But see Sadie Plant, *Writing on Drugs* (London: Faber & Faber, 1999), 49-51.

vi Alexander Herzen, *Ends and Beginnings*, tr. Constance Garnett, rev. Humphrey Higgens, ed. Aileen Kelly (Oxford: OUP, 1985), 429.

vii Ibid., 431-432. See pages 171 and 174.

viii I was advised that the thicknesses of print stocks for colour and black and white differed slightly, so that if reels were spliced together for projection, as they probably would be, there was a risk of losing focus at the splice. We could have printed the black and white footage on colour stock, but this tends to produce a slight tint.

ix See page 12.

x The name was suggested initially by its being that of one of the two itinerants Robinson and Delamarche in Kafka's *Amerika*.

xi On page 225.

xii See also Patrick Keiller, *The View From the Train* (London: Verso, 2013), 93-94, and Adrian Rifkin, 'Benjamin's Paris, Freud's Rome: Whose London?', *Art History* 22.4 (November 1999), 619-632.

LONDON
Camera subjects and notes

All dates 1992 unless otherwise stated

6–8 The *Seabourn Pride* arriving in the Pool of London, 30 April. The ship is approaching stern first.
1 'Étude de la grande Maladie de l'horreur du Domicile.' – Charles Baudelaire, *Mon coeur mis à nu*, XXI (36).

9 Vauxhall Estate, Hartington Road SW8, 4 March.

10–11 Abbey Creek, West Ham, with Hammersmith & City or District Line train, 29 January. Both lines run to Barking.

12 Corner of Rupert Street and Shaftesbury Avenue, 28 January. We were told that the school, upstairs, had initially offered courses in several languages and been named after Montaigne by its French founders, its scope later narrowing to English-only 'because of the recession'.
2 'Il fait bon naistre en un siecle fort depravé: car par comparaison d'autruy, vous estes estimé vertueux à bon marché' – Michel de Montaigne, *Essais*, Livre II, Ch. XVII, 'De la présomption'.
3 As far as anyone knows, Montaigne (1533–1592) never set foot in England; in 1585, the present-day Wardour Street was Colmanhedge Lane, but there weren't any houses. Perhaps Robinson is confusing Montaigne with Voltaire, who was in England between 1726 and 1728, though he lived in Covent Garden.

13–15 Sainsbury's Nine Elms, 17 March 1993.

16 Full moon, 10 December.

17 South Lambeth Road SW8, 2 February.

18–19 Palace of Westminster from Lambeth Bridge, 2 February.

20 Charles I statue, Trafalgar Square, 30 January.

21 The Banqueting House, Whitehall, 30 January, commemorating the execution of Charles I in 1649. Marks at the number two on the faces of the clock above the archway to Horse Guards Parade, opposite, indicate the hour of the king's execution.

22 Charles I plinth, 2 February.

23 MI6 headquarters under construction at Vauxhall, 6 February. Designed by Terry Farrell & Partners for Regalian Properties as an office development, the government's purchase of the project was agreed in 1988.

24–25 Gateway to Vauxhall Park, 8 February.
4 See Arthur Conan Doyle, *The Sign of the Four*.

26 Borough Road SE1, 9 February.

27 Old Kent Road SE1, 9 February.
5 Charles Baudelaire, 'The Salon of 1846' in *Art in Paris, 1846-1862: Salons and Other Exhibitions*, tr., ed. Jonathan Mayne (London: Phaidon, 1965), 46.

28–29 Burgess Park SE5, 11 February.

30 Bolina Road SE16, 11 February.

31 Government offices, 100 Parliament Street, SW1, 13 February. The telephone boxes have been replaced with older red K6 boxes at slightly different locations.

32 Lincoln's Inn Fields, 20 February. Formerly the encampment had been much larger. The last few residents were obliged to leave when the local authority, Camden, erected fencing in March 1993.

33 Alder tree at Imperial War Museum, Lambeth Road SE1, 20 February.

34 *The Burghers of Calais*, Victoria Tower Gardens, 27 February. A 1908 cast from Rodin's 1889 original.

35 South Lambeth Place SW8, 20 February.

36 South Lambeth Road SW8, 18 February.

37 Full moon, 18 February.

38 Vauxhall Estate, Hartington Road SW8, 25 March 1993.

39 Wandsworth Common, 10 March.

40 Railway cutting, Wandsworth Common, 11 March.

41 Clapham Common, 13 March.

42 Strawberry Hill, 12 March. The house is part of what was then St Mary's College, now St Mary's University. It was restored and opened to the public in 2011.

43 Teddington Lock, 12 March.

44 Pope's Grotto, now The Alexander Pope, Cross Deep, Twickenham, 19 March.

45 The Thames Path near Petersham, 19 March.

46–47 Petersham Meadows, 19 March.

48 View from Richmond Hill, 19 March.

49 Richmond Railway Bridge and Twickenham Bridge, 11 March.

50 London Road, Isleworth, 17 March.

51 Kew Railway Bridge, 31 March.

52–53 Thames flotsam at Mortlake, 31 March.

54 Hammersmith Bridge from The Mall, 2 April.

55 Harrods Depository, Barnes, 2 April.

56 Slipway outside boathouses, Putney Embankment, 2 April.

57 Refuse barges at Battersea Reach, Battersea Railway Bridge with goods train, 16 April.

58 Battersea Railway Bridge, closer, 16 April.

59 Battersea Bridge from left bank, 21 April.

60 Chelsea Bridge with beachcomber, 23 April.
6 Arthur Rimbaud, 'Les Ponts', *Les Illuminations*, XIV.

61 Lambeth Bridge with refuse barges, 23 April.

62–63 Battersea Power Station from Vauxhall Bridge, 2 May.

64 Incoming tide at Battersea Bridge, 21 April.

65 *Financial Times* print works, East India Dock Road E14, 1 April. Designed by Nicholas Grimshaw and Partners and listed grade II* in 2016, the building is now a data centre.

66 St Mary le Strand, south side, 8 April.

67 St Mary le Strand, gates and west facade, 8 April.

68 Strand Theatre, Aldwych, 21 April. Renamed the Novello Theatre in 2005.

69–70 Savoy Hotel, views from room 509, upstream towards Charing Cross Bridge and Vauxhall, downstream to Waterloo Bridge and the National Theatre, 7 April. In 1992, rooms 508 and 509 were the hotel's 'Monet Suite'; in 2010, it was demonstrated that Monet's fifth-floor views were from the balcony of the neighbouring suite, rooms 510 and 511. See Soraya Khan et al., 'Monet at the Savoy', *Area* 42.2, 208-216.

71 Wyvil School, South Lambeth Road SW8, 9 April.

72 Bus terminus, Putney Heath, 9 April.
7 H G Wells, *The War of the Worlds*, Book 2, Chapter 7.

73 Green Man, Wildcroft Road SW15, 10 April. According to Edward Walford's *Old and New London: Volume 6* (1878), Chapter 36 'Putney', Thomas Cromwell's birthplace, his father's blacksmith's shop, was traditionally located at the site of the Green Man.

74 Westminster Library, Charing Cross Road, 9 April.

75 Smith Square, 10 April.

76 Downing Street, 10 April.

77 *Financial Times* print works, East India Dock Road E14, 10 April.

78 View east along Cornhill, 11 April.

79 Corner of Cornhill and Lombard Street, 11 April.

80 View north across Leadenhall Street, 11 April.

81 Lime Street, 13 April.

82–83 Commercial Union tower from Lime Street, 13 April.

84 Staples Corner flyovers, wreckage of B&Q store, 14 April.

85 Edgware Road NW2, 14 April.

86 Brent Cross Shopping Centre, 15 April.

87 Vauxhall Park, south-west gateway, 20 April.

88 Vauxhall Park, 20 April.

89 Upper Ground SE1, 28 April.